Lyudmila and Natasha

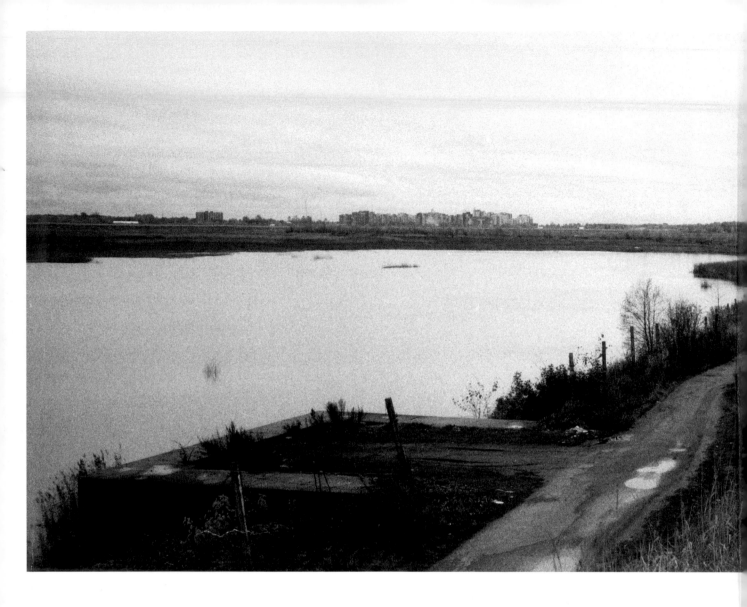

Lyudmila and Natasha
Russian Lives

Misha Friedman

THE NEW PRESS

Requests for permission to reproduce selections from this book should be mailed to:
Permissions Department, The New Press, 120 Wall Street, 31st floor, New York, NY 10005.

Published in the United States by The New Press, New York, 2014
Distributed by Perseus Distribution

ISBN 978-1-62097-023-2 (pbk)
ISBN 978-1-62097-054-6 (e-book)
CIP data available

The New Press publishes books that promote and enrich public discussion and understanding of the issues vital to our democracy and to a more equitable world. These books are made possible by the enthusiasm of our readers; the support of a committed group of donors, large and small; the collaboration of our many partners in the independent media and the not-for-profit sector; booksellers, who often hand-sell New Press books; librarians; and above all by our authors.

www.thenewpress.com

Book design and composition © 2014 by Emerson, Wajdowicz Studios (EWS)
This book was set in Helvetica Inserat, Helvetica Neue, Franklin Gothic, News Gothic and Roman Cyrillic Std.

Printed in the United States of America

10 9 8 7 6 5 4 3 2 1

Preface
By Jon Stryker

The photographs in this book and future books anticipated in this series are part of a larger collective body of commissioned work by some of the world's most gifted contemporary photojournalists. The project was born out of conversations that I had with Jurek Wajdowicz. He is an accomplished art photographer and frequent collaborator of mine, and I am a lover of and collector of photography. I owe a great debt to Jurek and his design partner, Lisa LaRochelle, in bringing this book series to life.

Both Jurek and I have been extremely active in social justice causes—I as an activist and philanthropist and he as a creative collaborator with some of the household names in social change. Together we set out with an ambitious goal to explore and illuminate the most intimate and personal dimensions of self, still too often treated as taboo: gender identity and expression and sexual orientation. These books will reveal the amazing multiplicity in these core aspects of our being, played out against a vast array of distinct and varied cultures and customs from around the world.

Photography is a powerful medium for communication that can transform our understanding and awareness of the world we live in. We believe the photographs in this series will forever alter our perceptions of the arbitrary boundaries that we draw between others and ourselves and, at the same time, delight us with the broad spectrum of possibility for how we live our lives and love one another.

We are honored to have Misha Friedman as a collaborator in *Lyudmila and Natasha*. He, and the other photographers among our partners are more than craftsmen; they are communicators, translators, and facilitators of the kind of exchange that we hope will eventually allow all the world's peoples to live in greater harmony. ■

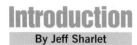

Introduction

Here is a book about a couple, Lyudmila and Natasha, who appear in these photographs to be in love with one another, and who say they are in love, and who struggle. Because that's what we do when we're in love. We struggle to hold on—to one another, to ourselves, to a moment that is always leaving. It's like trying to hold on to a river, as if Lyudmila and Natasha have attempted to wrap their arms around the Neva with which this hard, beautiful, struggling book begins. Hold on to a river? Impossible. It can't be done. And yet we try, we try. This is our struggle as people in love, or people who remember love, or people waiting for love's return; that is why we recognize ourselves in Lyudmila and Natasha, two ordinary women in love, remembering love, waiting for each other's return.

See Lyudmila and Natasha on the cover, chin to nose like yin and yang, lips between seeking connection. Contact, a kiss, completion. But it's never so simple. Chapter 1 opens with individual portraits, Lyudmila and Natasha each alone, separated from one another, broken up. Each speaks to Misha Friedman, to the camera, and through the camera to one another: "I would like to be with Natasha," says Lyudmila, in soft light and gentle shadow. "With my love." Natasha—sun drawing a sharper line across her eyes—"I don't have superhuman powers to fall in love just because I want to."

But she does. That's the spoiler. This is a love story, after all. Common as water, as hard to grasp as a river. That Misha Friedman comes so close is his great achievement, his gift to us. Friedman has become like one of Wim Wenders's angels in *Wings of Desire*, a recording angel, an angel with a notebook and a camera, documenting the ordinary and by doing so revealing it as extraordinary. There are no iconic images here, no *V-J Day in Times Square* kiss, no Doisneau's *Le baiser de l'hôtel de ville.* Instead of the grand gesture, we have the real embrace. Consider Natasha through Lyudmila's eyes as they make love (page 137), Natasha stunned and yet searching, seeing Lyudmila so fully that we see her, too. We are looking over Lyudmila's shoulder and yet seeing with Natasha's eyes. Fleeting yet intimate, like water rushing around us.

These are the moments I prize most in *Lyudmila and Natasha*, but they're not why I've been asked to write an introduction. My connection—beyond the human one anyone with eyes and heart can share with images as grainily specific and universal as these—is with the setting for Lyudmila's and Natasha's love and struggle, Saint Petersburg: in particular, Russia more widely. It's not my setting—I am neither a Russian nor a Russophile; I admire Saint Petersburg, but I cannot name the streets in these pictures. I am no expert. All I know is Article 6.21, signed into Russian law by President Vladimir Putin on June 30, 2013, after a vote in the Duma of 436–0.

The language of the law is dull and deliberately vague, designed to deter close reading. So let us struggle with it:

> **Propaganda of nontraditional sexual relations among minors, manifested in the distribution of information aimed at forming nontraditional sexual orientations; the attraction of nontraditional sexual relations; distorted conceptions of the social equality of traditional and nontraditional sexual relations among minors; or imposing information on nontraditional sexual relations that evoke interest in these kinds of relations—if these actions are not punishable under criminal law—will be subject to administrative fines.**

It's almost genius in its perversion. Consider, especially, the third clause, outlawing "distorted conceptions of the social equality of traditional and nontraditional sexual relations." What does it mean? Only this: in Russia, now it is a crime for Lyudmila and Natasha to assert that their love matters as much as that of a man and a woman. It is a crime to assert that they could ever even love each other as much as a man and a woman. If Lyudmila tells her two sons that she loves Natasha just as much as their father loves their stepmother, she is breaking the law. She might be forbidden from seeing her children.

Article 6.21 does not forbid sexual relations. It is not a revival of the Soviet-era Article 121, which punished sex between men with prison terms as long as five years. (Only men—lesbians and other queer relations were, apparently, beyond the throttling grip of Stalin's imagination.) Article 6.21 is subtler than that. It's more like a resurrection of the Soviet-era Article 70, which simply—simply!—banned "anti-Soviet agitation and propaganda." What constitutes propaganda? The police will inform you after your arrest. Or they may not. Best not to say anything at all. So, were it not for the fact that until just a few years ago LGBT rights in Russia were steadily advancing—were it not for the fact that a proposal similar to Article 6.21 was laughed out of the Duma as hopelessly provincial without a vote as recently as 2006—were it not for these facts we might say Article 6.21 provides a kind of progress. It's not as all-encompassing as Article 70. Article 6.21 provides focus. It's concerned with merely one or two aspects of life: love and sex, sex and love, and, for good measure, anything to do with children, because we must protect the children. From what?

The police will inform you after your arrest. Or they may not. Best to say nothing at all.

This book could be illegal in Saint Petersburg, Lyudmila and Natasha and Friedman subject to arrest and fines. Or worse. At Russia's first Pride parade, in 2006, police arrested the organizer, Nikolai Alekseev, at the outset. He turned out to be the lucky one. A few Pride marchers made their way to City Hall and a statue of Yuri Dolgoruky, Yuri Long-Armed, founder of Moscow, who was to have greeted them at the end of the parade that didn't happen. A deputy of the Duma was waiting, leading a crowd in a cheer: "Gays and lesbians to Kolyma!"—the Gulag. A gay member of the German Bundestag tried to unfurl a rainbow flag. The crowd beat him until his face was bloody. Police looked on.

A French activist escaped. A mob ran after him and a dozen took him down. "I thought I was going to die," he said, but then they moved on. He stood up, his face and hands red and slick. He was on Tverskaya, Moscow's grandest shopping boulevard. He asked for help. The shoppers streamed around him. His attackers came back. They beat him some more. Police looked on.

So it has gone every year since, beatings and arrests, sometimes arrests and then beatings, until 2013, when the police preempted the marchers. They brought special trucks fitted with metal cages. In 2014, during the Sochi Olympics, a small group of protesters attempted to gather in Red Square. One tried to sing the national anthem, but the police beat her just the same. I watched it on YouTube, moments after it happened, horrified, of course, and then alarmed: the woman going down singing—I knew her. It was Elena Kostyuchenko, whom I'd written about for a magazine—Elena, one of the bravest women I've met.

The sad truth was that I knew she could take it. Elena's used to such beatings. She'd been beaten and stoned and arrested more times than she could count. Once, a group of Christian activists sent their children to attack her and her fellow protesters, at a kiss-in in front of the Duma, twelve-year-old boys punching and cracking noses of queer men and women who knew they'd be punished for assaulting children if they tried to defend themselves. Elena's first Pride parade—or, rather, her first attempt at a parade—was in 2011. She went because she'd fallen in love. She and her girlfriend, Anya, wore T-shirts that said, "I love her," with arrows pointing to one another. They were very afraid. Anya kept repeating a child's proverb. Something her mother used to tell her when she was scared. "There is a rhyme in Russian, it sounds more beautiful in Russian," Elena told me, but I don't speak Russian, so she said it to our friend Zhenya, who translated it for me: "You angels go forward," he said softly, rippling his fingers on the table. "We will follow."

Lyudmila and Natasha is not, in essence, a political book. Chapter 5 begins with seven photographs of Natasha at a small LGBT protest—the release of a rainbow of balloons—in Saint Petersburg; but even here Friedman draws our interest not to the event, not to the "religious zealots," as he calls them (but hardly a fringe—only 7 percent of Russians say they firmly oppose Article 6.21), nor to the police keeping an uneasy peace. Rather, we learn more about Natasha, alone even within community. So much of this book about being together is dedicated to pictures of these two women being painfully alone. The previous chapter shows us Lyudmila and Natasha's fights and breakups; it ends with an image of Lyudmila alone, bent over, little more than a black shape hiding behind blankets on a couch—her ex-husband's apartment— darkness pressing in on her.

Chapter 5 opens with a rainbow of sunlit balloons, but the camera must go through the zealots to reach them. And then there is Natasha, her arm raised into the sun, holding balloons, a red, a green, and an orange. Pretty. But Friedman follows her past the colors, drawing our attention to details of body and character—her set jaw as she passes a sullen officer; the narrowness of her shoulders as she almost seems to tuck a cigarette up to her lips; riot cops, truncheons drawn, blurry behind her. That's how we leave the protest, the explicit politics of this book: with Natasha alone before the blur of the police, her neck bent, as if weighed down by her silver chain, her face almost divided in two between her lips, a broad, elegant bow, and her eyes, weary and swollen, a brow plucked thin and arched as she looks away. It is not a hopeful image.

What follows is surprising—Lyudmila and Natasha with other women. I find these sadder to look on than the political photographs. But then, they are political pictures in a sense, a point Friedman makes when he captions a photograph of the two women together in sullen silence, "The grim future for LGBT community in Russia and intolerant attitudes toward their relationship adds an extra level of stress to it." Indeed. In my interviews with LGBT Russians I met a teacher forced out of her job, a man shot in the eye, men and women contemplating exile, men and women retreating to the closet, a lesbian who had resolved to try heterosexuality. I met a man whose straight friends had been beaten for trying to protect him and a straight man who wanted to teach queer Russians how to use weapons to defend themselves. There was one man, Nikolai, who said he didn't worry about homophobia, "because I always carry a gun." Another, Yuri, wanted me to send a message to his queer countrymen: "No more parades! No more marches!" The price was too high. Russia must return to the past.

Maybe it already has. We met at a Saint Petersburg gay bar called Bunker, which is really a maze, twisting through the rest of the building's vast basement. It's dark; you have to feel your way through. That's the point: the men who go to Bunker, many or maybe most of them "straight" men, says the bartender, married men, grope their way into the maze looking for bodies, not faces. They don't want to see or be seen, only to touch, to be touched, in a place where nobody knows them.

And yet here are Lyudmila and Natasha living in the present. Beyond banners and marches, in these photographs we see another kind of resistance, that of the mundane, plain existence as a contradiction of hate: dancing at a club—crowded, colored lights, exhilarated people—Natasha's hand slipping up Lyudmila's skirt, the two of them holding hands in the street, a walk in the woods with Lyudmila's children, bringing a piece of fruit to a neighbor. The neighbor is an addict; Natasha used to be one, too. Sometimes solidarity is as simple as that: recognition and an apple.

The question of solidarity haunts these photographs, solidarity not in the political sense but on a personal level. Friedman keeps bringing us back to images of each woman alone, such as the sequence of Natasha being tested for tuberculosis: sitting in a desolate hospital corridor, stripping off her shirt for the exam, and then the X-ray, four squares of light across her back like a four-paneled window. Such paneling recurs throughout the book, at the start of each chapter, windows into Lyudmila's and Natasha's lives. But it is only at this moment of Natasha's aloneness that we see the pattern for what it is: an X-ray, a deeper peering within.

This is a story about Russia, but it could be about anywhere. Last year, the Supreme Court of India, home to a much bigger, more vibrant out population than Russians can even dream of, undid the de facto legalization of homosexuality that had occurred just four years previous; a court in Australia invalidated the gay marriages it had allowed for five days; and Africa's most populous, dynamic nation, Nigeria, followed the example of Uganda by making homosexuality —already long illegal—a kind of public enemy, an organizing principle; and somewhere in

America—many, many places in America— some kid is being kicked out of his house or being beaten or Googling how many pills it will take, or fingering the blade, or driving toward a tree now. We will know why some of them died. Others will just be gone.

And yes, it gets better—it will get better in Russia, too. This is what my friend Tanya told me one night in Saint Petersburg, riding back into the city from a gathering of homophobic organizations at which she'd translated my questions and a series of ever-more frightening answers as our hosts entertained us with an iPad slideshow of bloody faces—their "greatest hits," one man joked. The haters also like to take pictures. "Those fuckers," Tanya said as we rode back to the city. "They're going to lose," I said. And it is probably true—if Article 6.21 represents something darker than a backlash, a new kind of nationalism, it is nonetheless not likely the future. And on such grounds, too many good people ignore the new Russian homophobia, as if they can simply wait for it to pass.

Someday. But what about the meantime? Russians do not speak of lives ruined; they say they are broken. It's a more precise term: not romantic but mechanical. A continuity, a story, a life: shattered.

Lyudmila and Natasha are not, in these pages, at least, shattered. Broken up at times, but not broken. "Stressed," as Friedman writes, but enduring. Only *enduring* is too plodding a term for the movement Friedman follows. See them curled into a ball together (page 36), Lyudmila's red hair veiling Natasha's wary eyes. Or lying down, forehead to forehead (page 38), their hair and their lashes and even their ears echoing, as if drawn in one continuous sweeping line, as if the lines of their faces were letters written in a private language. Swoon for Lyudmila and Natasha on page 130, the grain of the photograph making them as one, laugh with them on page 145, see them between the dark coats of a crowded subway car, their foreheads touching again, their true pose together, recurring throughout the book, an act of physical telepathy. Watch them return to one another again and again, like currents in a river, one that Misha Friedman has allowed us to hold on to for a brief while. ■

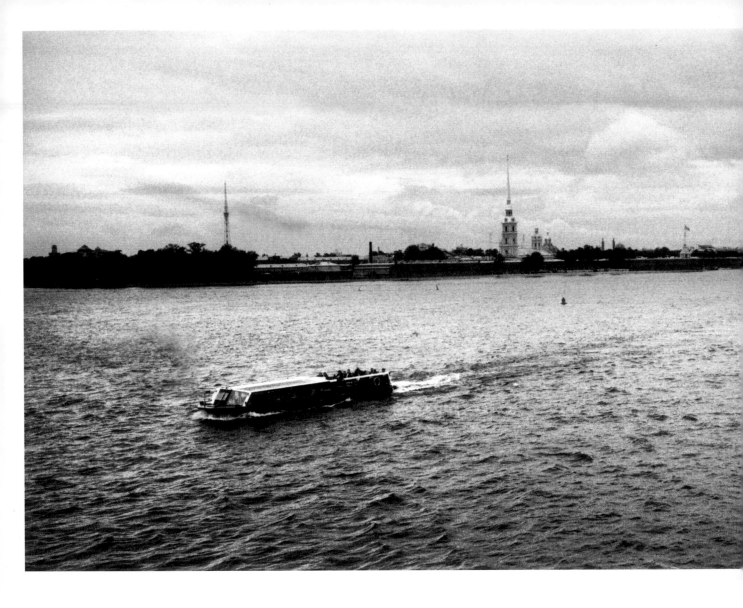

The Neva River in central Saint Petersburg.

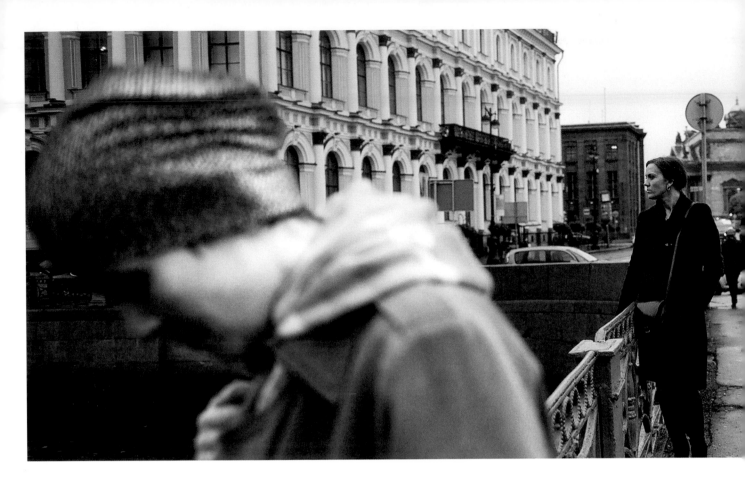

The weather is bleak in Saint Petersburg for most of the year, and the surrounding grand Russian Imperial architecture provides a moody backdrop for romantic walks. Living on a small budget, Lyudmila and Natasha can only rarely afford to go out to clubs or restaurants. For the most part they spend their time together at home, or wandering the streets in the center of the city.

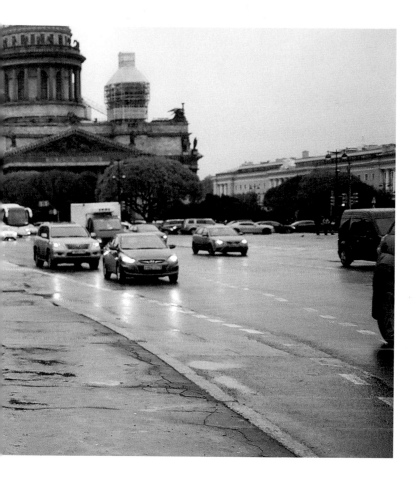

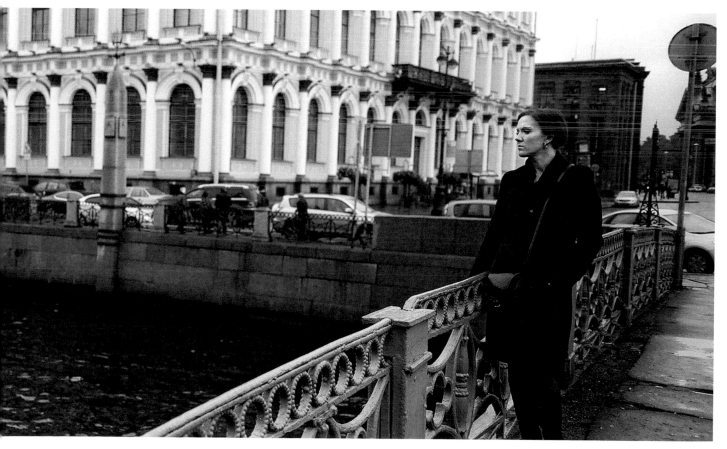

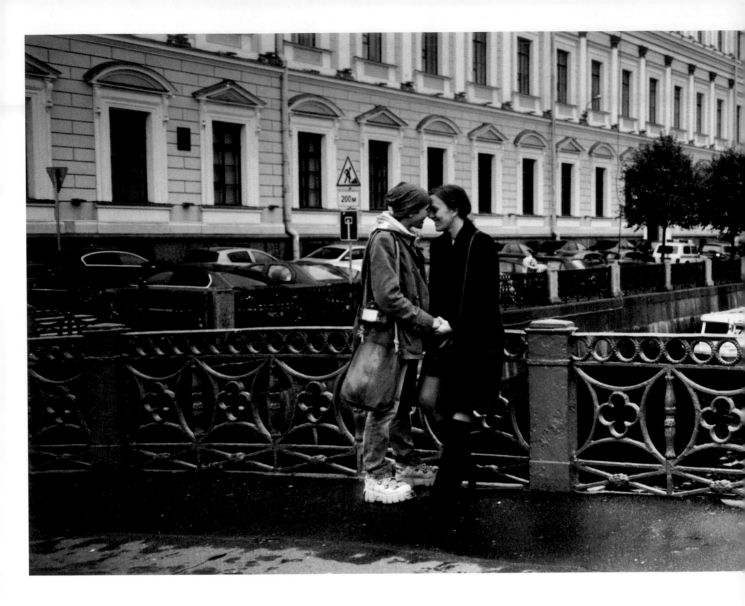

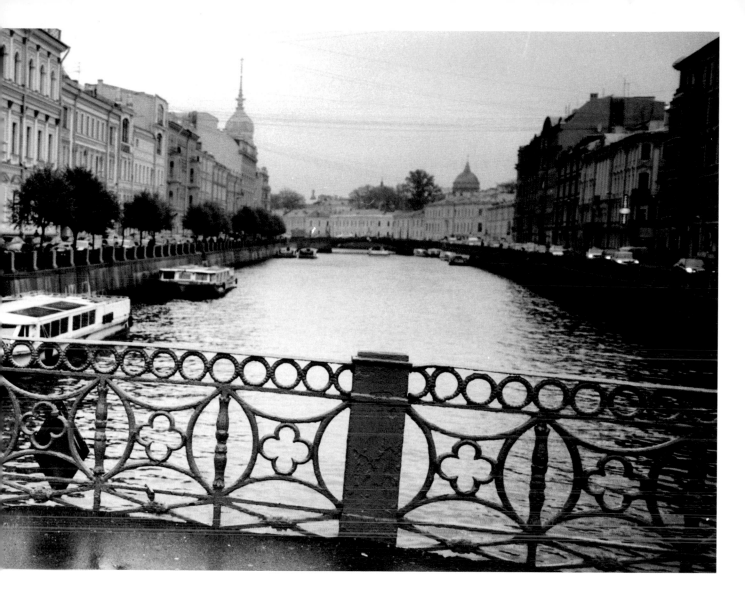

Lyudmila and Natasha on the Blue Bridge over the Moika River in central Saint Petersburg

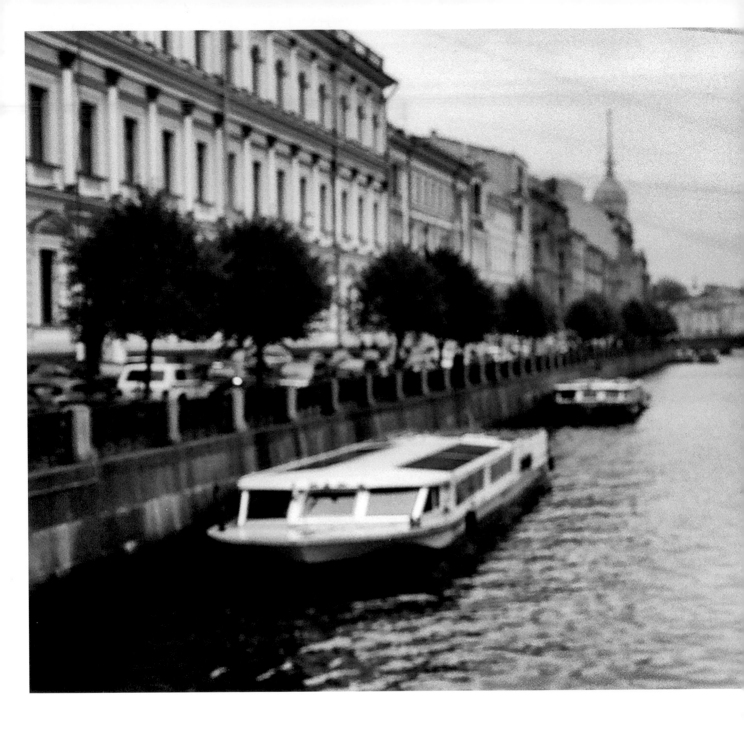

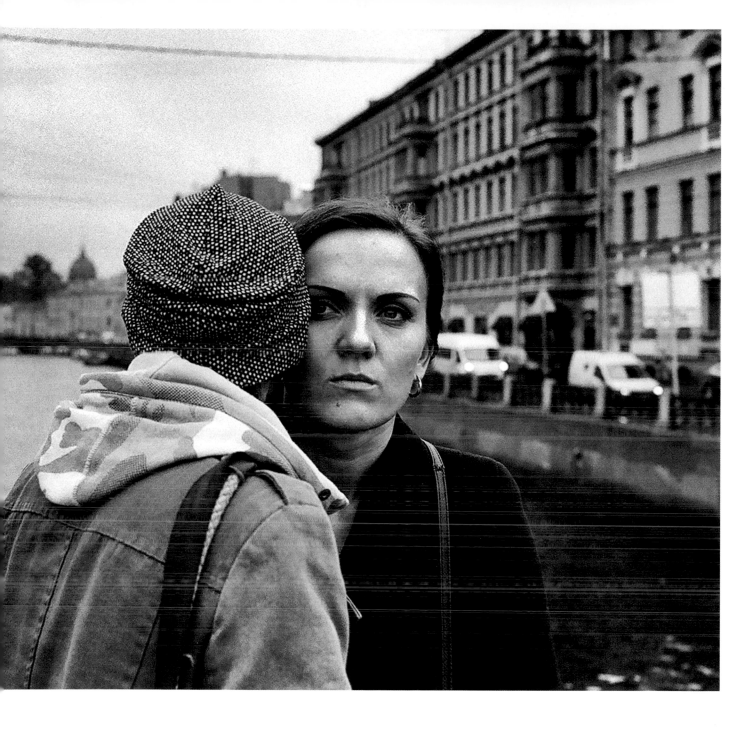

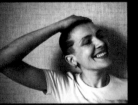
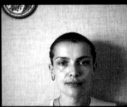
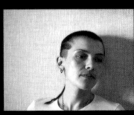

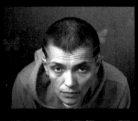

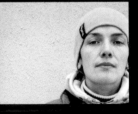

Natasha

____What does love mean to you?

Love is a feeling, a desire . . . but really, I am not sure what it actually means to me. It could mean a lot of things, apart from the obvious sensation. It's closeness. A person with whom I'm in love is my best friend. Trust. All of life is based on trust. I'm not going to go into all the details, but love is understanding another person in the same way one understands oneself. I really don't care for such terms as love of life, love of motherland, love of potatoes, or love of bananas. For me love is only about a person.

____Are you ready to love someone else?

I don't think in such terms any longer. I am not living and waiting to fall in love. I'm not sure how it happens. So I don't have such plans. I would like this to happen, but I don't have superhuman powers to fall in love just because I want to.

____How do you identify yourself?

As Natasha. My passport, it says I'm Russian. I've got three different nationalities in my blood, but I'm Russian. The same is true with my sexuality: I don't feel like I'm a boy, so I'm simply Natasha. I identify myself as a woman, and all other questions don't bother me. So I'm called a lesbian. When I say I'm Natasha, I simply feel like a human being. When I say "lesbian," I don't feel a thing. That's a finger [holding up her finger] but it doesn't care what the word is. The same with me, I don't care, I simply live.

____What did you have to overcome in life?

I have constantly had to mature. Everything else is ordinary life. We live in a country, a society where "overcoming something" is standard. It's normal, because any stability is absent. So such things in my life, like quitting drugs, detoxing, are not really obstacles for me. For me it's a choice between doing those things or death. So a better question would be, what did I have to learn, what did I have to change? Probably the biggest obstacle was self-realization, or an attempt to see self-deceit. I think that's the biggest thing I had to overcome, or any other person has to overcome in life. Because the worst thing to do is to say, "I'm bad" and that's that. Maybe the worst thing is not even to say that, but to accept some bad characteristics in oneself, understand them, and protect them. So this was difficult to overcome.

____What are your hopes for the future?

I would like to have a family very much. Because for me, it's very important to know that others need me, that I'm loved. I hope photography works out for me, because I have little confidence in myself. But most importantly, I hope I'll have enough time to complete all of this. I don't like talking about this. For me it's key. I quit doing drugs, started to live somehow, but it's very difficult to live. I really want to—to have enough time to do something meaningful, to leave something behind. I hope I will be able to. I hope I have time. I just need to make an effort.

____What are you afraid of?

I'm afraid of heights for the first five minutes after climbing somewhere. Well, what is a person afraid of? Death, for the most part. To become an invalid, helpless, powerless. That's probably the biggest fear, to become powerless. This feeling of loneliness and powerlessness. And the scariest part of that is when nothing can be changed anymore. This feeling of being in a situation where there's no help coming from anywhere, and no hope for any change. That's probably the scariest situation, where it's impossible to change anything. While life is moving, it's great. If someone were to leave me without any communication in an enclosed room, that would be like an endless self-conversation; that would be very scary. It's probably better to kill criminals than to sentence them to a life of solitude. That's more humane, I think.

____Are you missing something without Lyudmila?

I'm missing faith. I no longer have faith. I'm open but I'm not ready. I miss our first-and-a-half years of life together. But that person is long gone. I don't feel well, and I can't sleep most of the time.

Natasha in the apartment of a friend, who is a hairdresser.

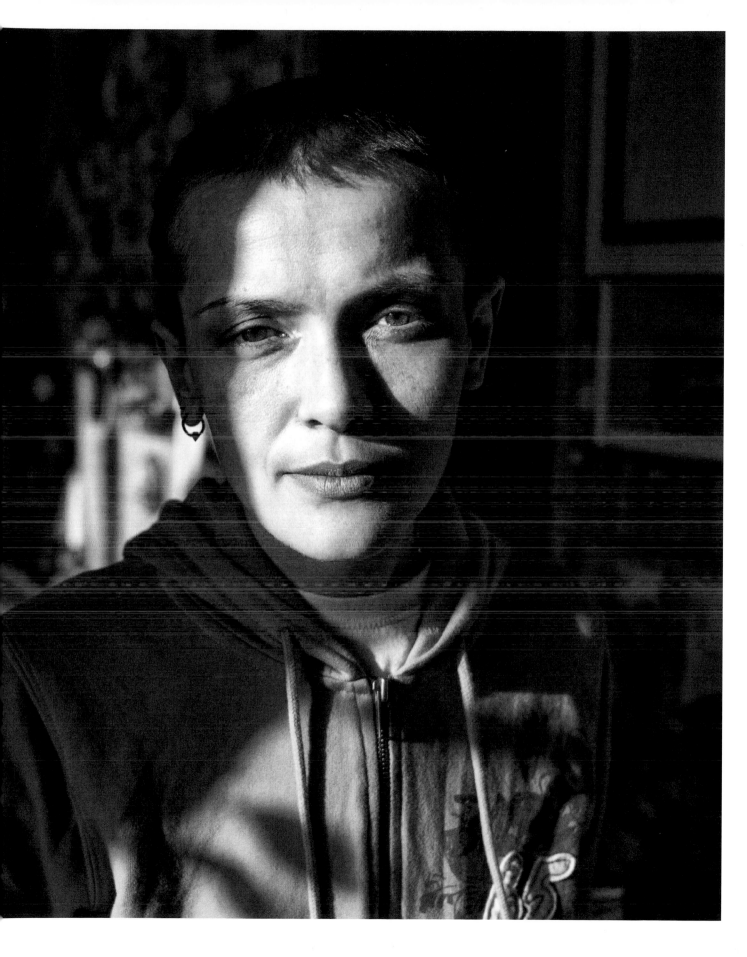

Lyudmila

____What does love mean to you?

Love is understanding and respect. Love is everything. Without love, a person is dead. It's happiness, it's sorrow, it's laughter, it's tears. It lives right here, where the soul is, a little blob, that's where love lives.

____Are you ready to love someone else?

I don't know. If I were to judge by the statistics, some people love one another really strongly, some love all of their lives, some forget, some fall in love with other people. But there's also a difference between love and a crush. A crush passes. And love is this warmth which lives here in one's chest. Even if people who are in love split apart, this feeling remains—it's not as strong, but it still has a faint warmth. And it remains there for the rest of one's life. Memories, recollections, sensations, it all stays behind.

____How do you identify yourself?

I feel like a man in a woman's body . . . it's difficult to answer. I can be active like a man, or passive as a woman. There are also men who I like, with whom I flirt. But maybe that's just nature, women always flirt with men. I don't do it often and I don't know why. But it doesn't mean anything really. It's like a game, communication with no consequences. I don't really flirt with women, because it's serious—it can lead to feelings: love.

____What did you have to overcome in life?

I know for sure that I have no regrets. That my children live separately from me is my choice. I miss them but I don't regret it because it's my choice. Everything in life is a decision, like splitting from someone you love, or divorcing. They're simply decisions. I still haven't told my relatives of my life choices. My mom found out from someone else, but I'm still not ready to "come out." It doesn't matter who I love, with whom I sleep, or with whom I live. But it's probably fear. And also, I feel like it doesn't matter.

____What are your hopes for the future?

I would like to be with Natasha, with my love. But it's all murky, so I am really not sure about my future. It's all covered in fog, I live from day to day. I hope that Zamanskaya and my children will be with me in the future. But if it's not going to be her, then there has to be some other person who I would trust, to whom I would be as close. Home, family—that's what I would like to have.

____What about fears?

I fear living the rest of my life without my children, I fear loneliness, I fear not meeting anyone else, I fear not seeing Natasha ever again.

____What do you miss about Natasha the most?

I miss our home, I miss seeing her back (as she spent all of her time at the computer for the past three years). I miss constantly running children screaming "Mama! Mama!" I miss this feeling of being at home, where everything is so familiar, warm, and close.

Lyudmila smoking in a stairwell outside her apartment.

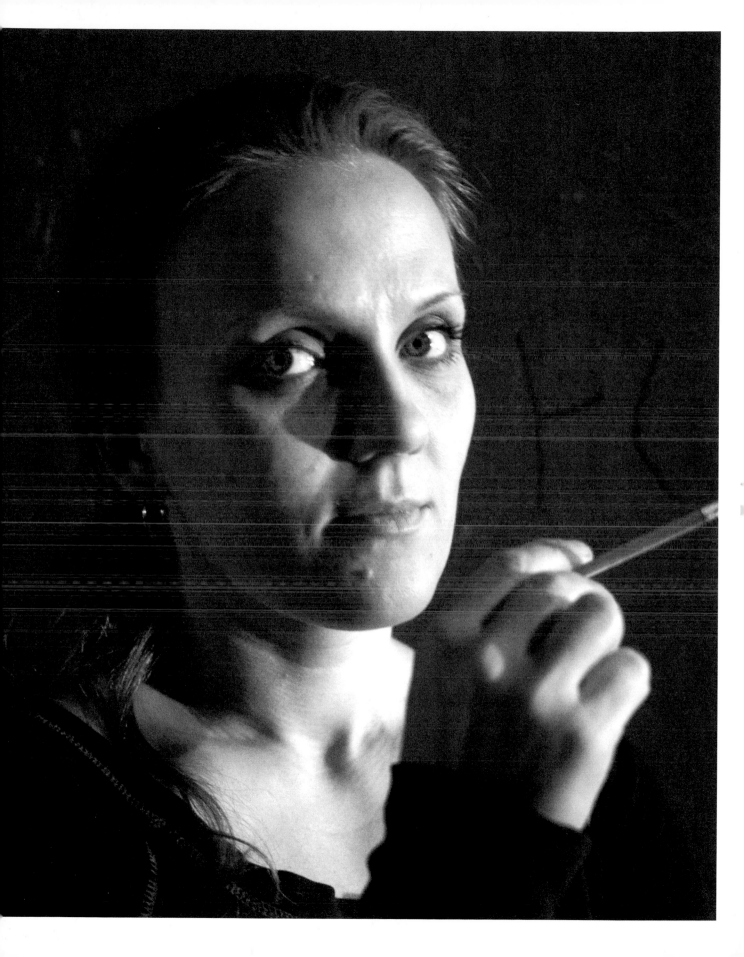

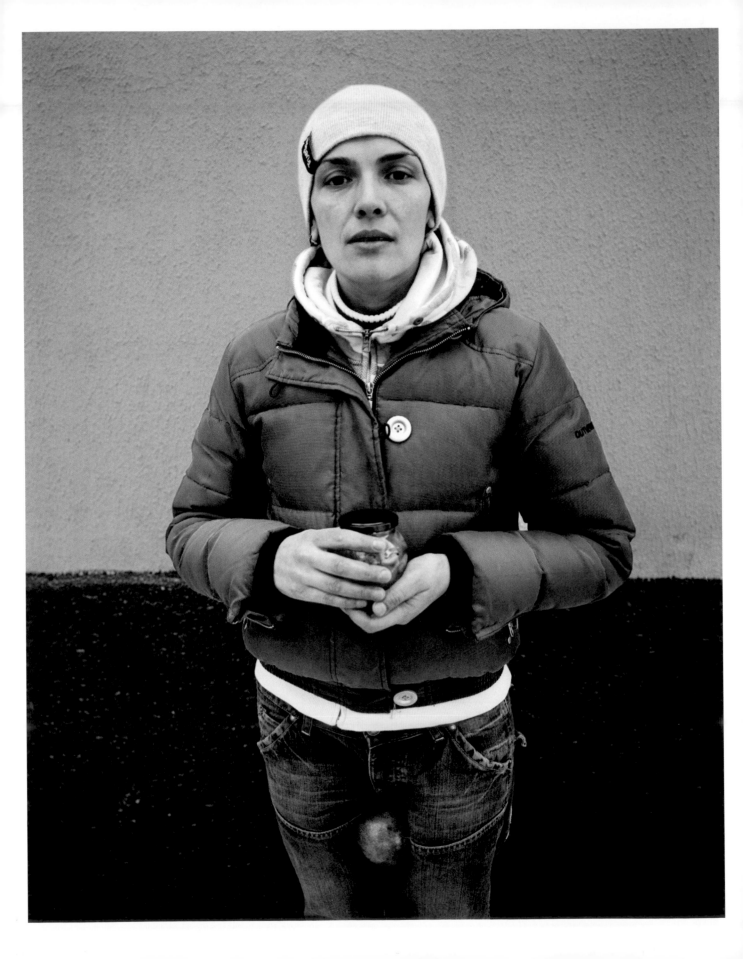

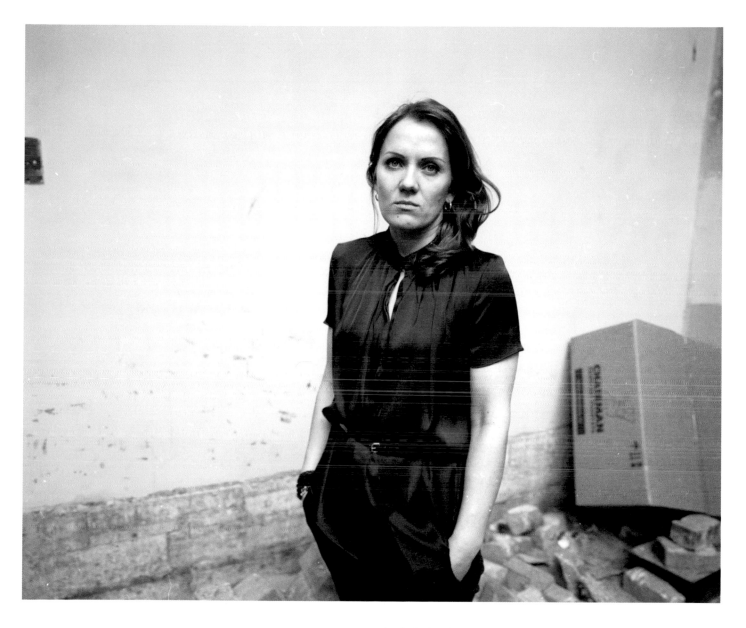

Lyudmila at work, at a restaurant on Nevsky Prospekt in central Saint Petersburg.
Natasha taking food to her neighbor, a drug addict, who can't afford to buy anything herself.

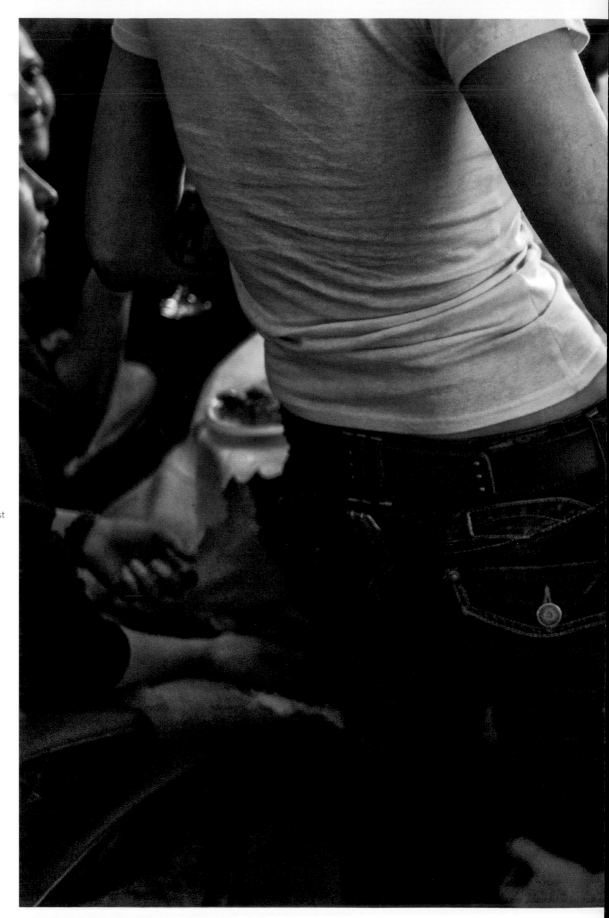

Natasha brought Lyudmila to a birthday party of one of her friends, a former drug addict and a lesbian. Though not her crowd, Lyudmila supports Natasha by attending such gatherings, which are almost informal AA meetings.

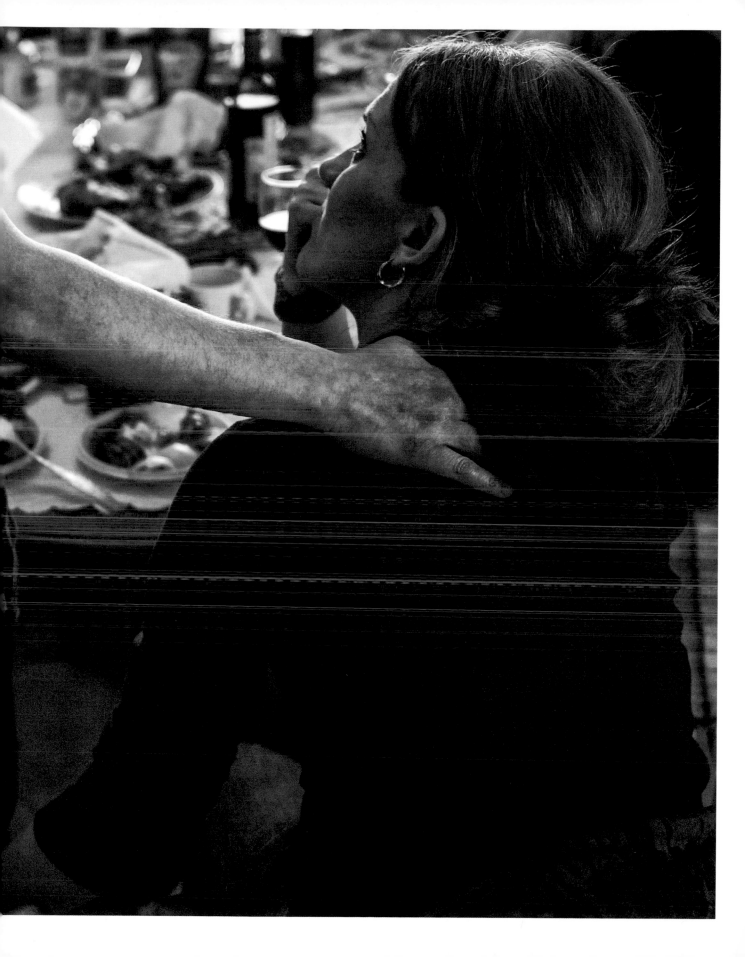

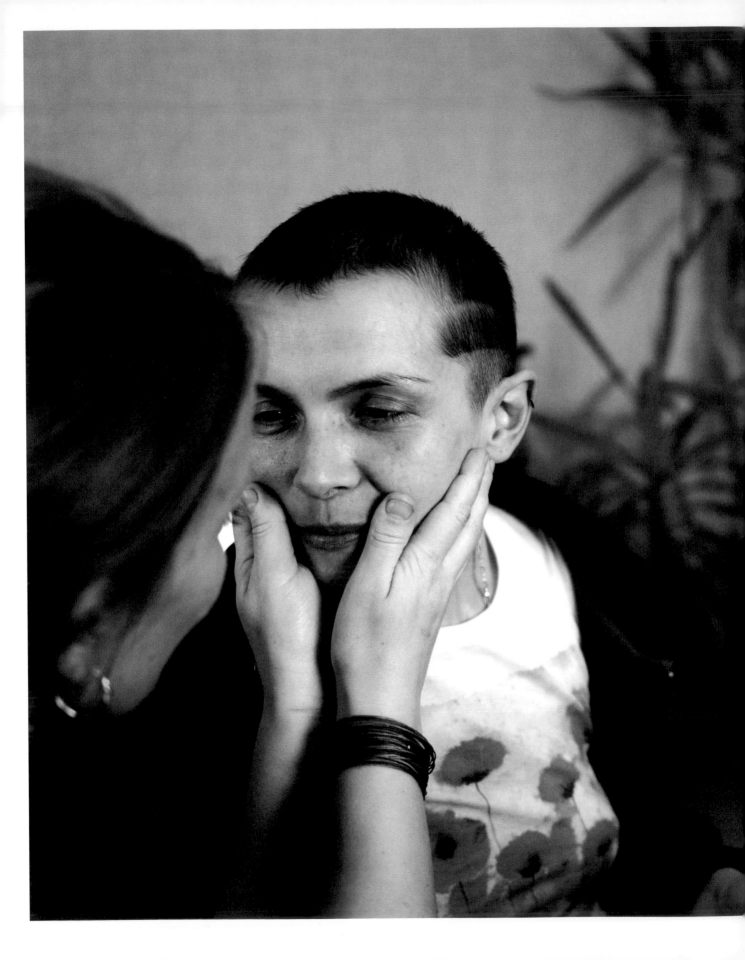

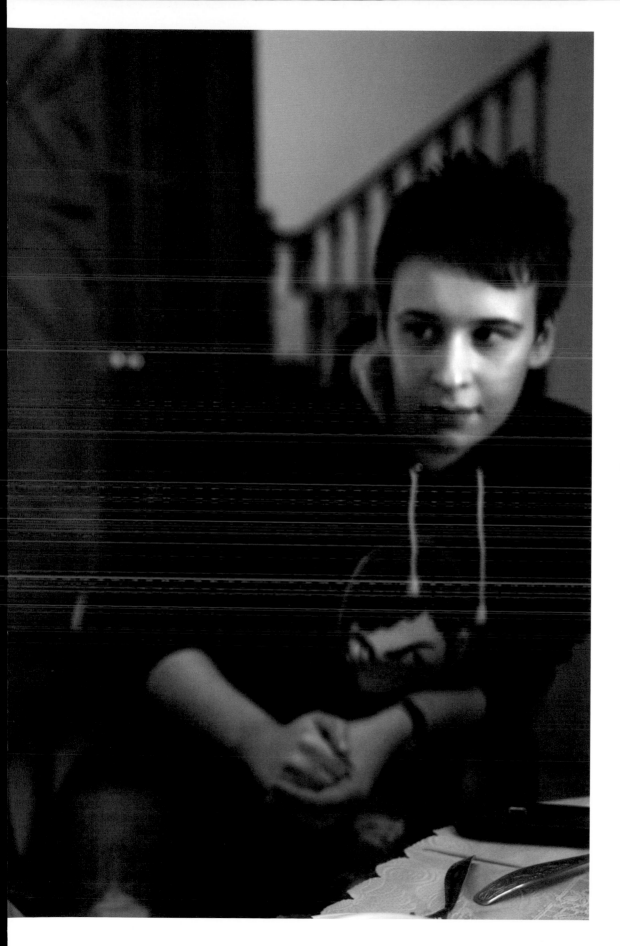

Lyudmila holds Natasha's
face as their friend looks
on, at a birthday party.

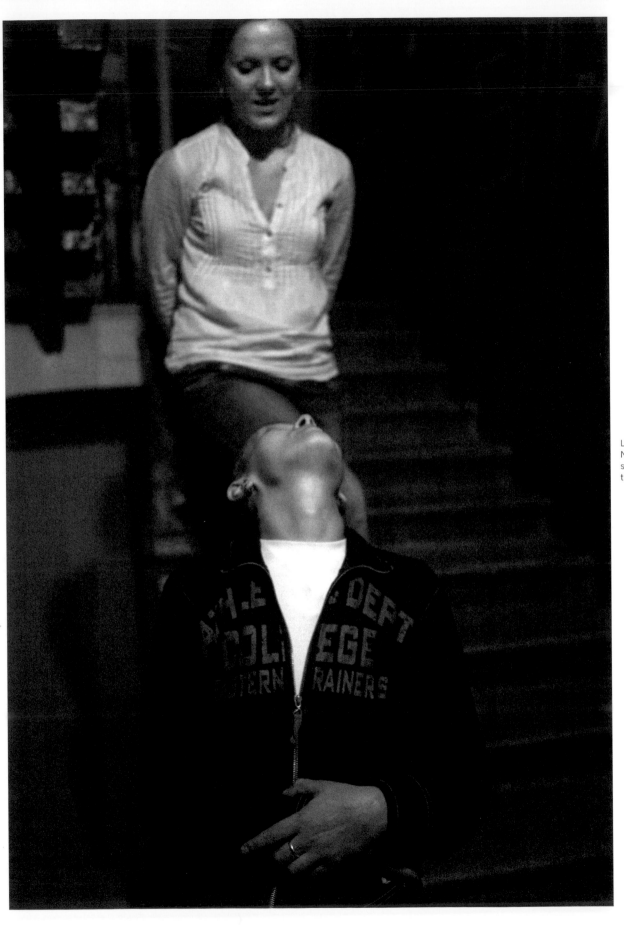

Lyudmila and
Natasha in a
stairwell outside
their apartment.

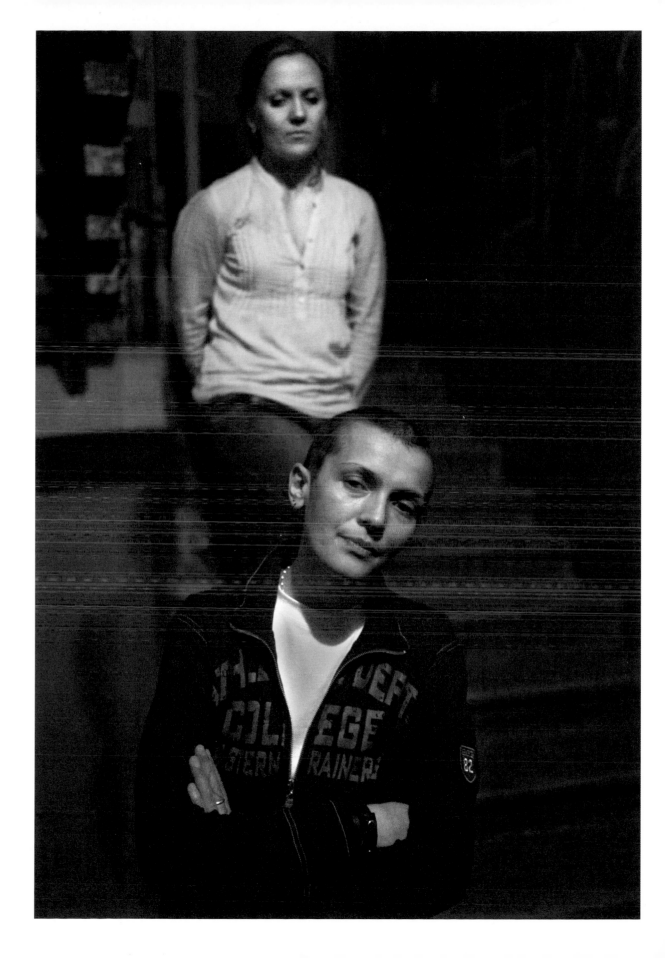

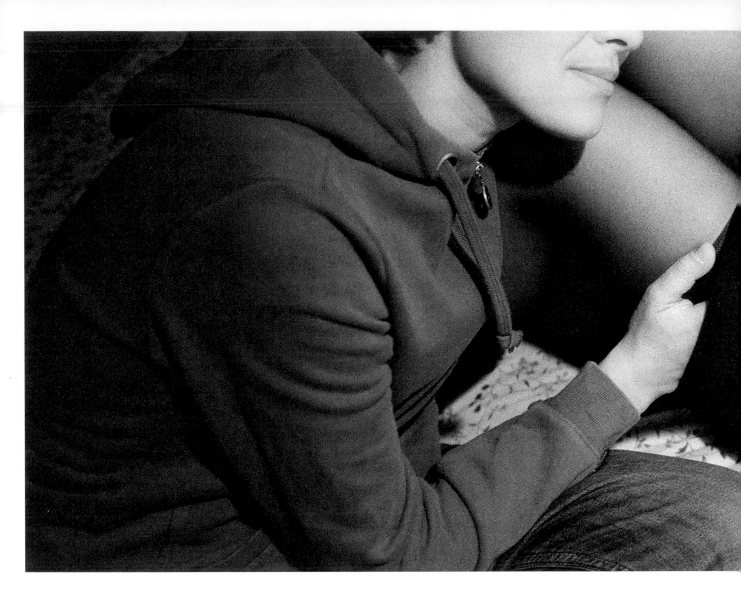

An intimate moment after a fight.

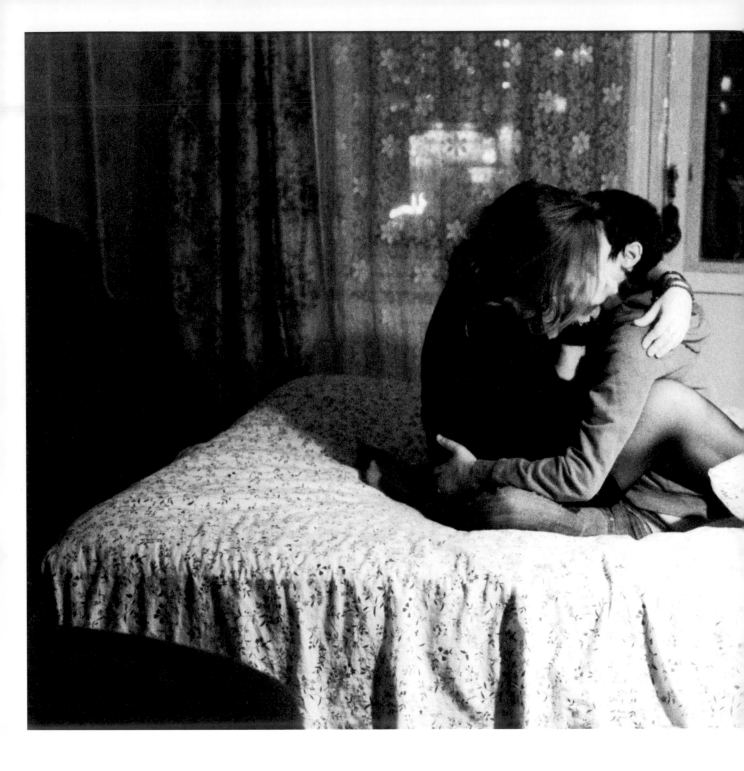

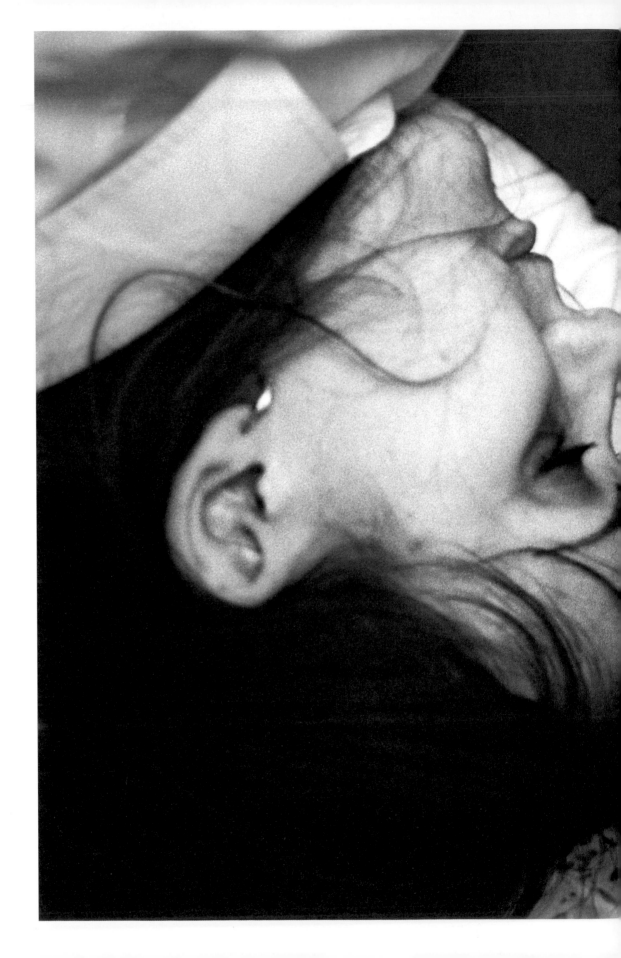

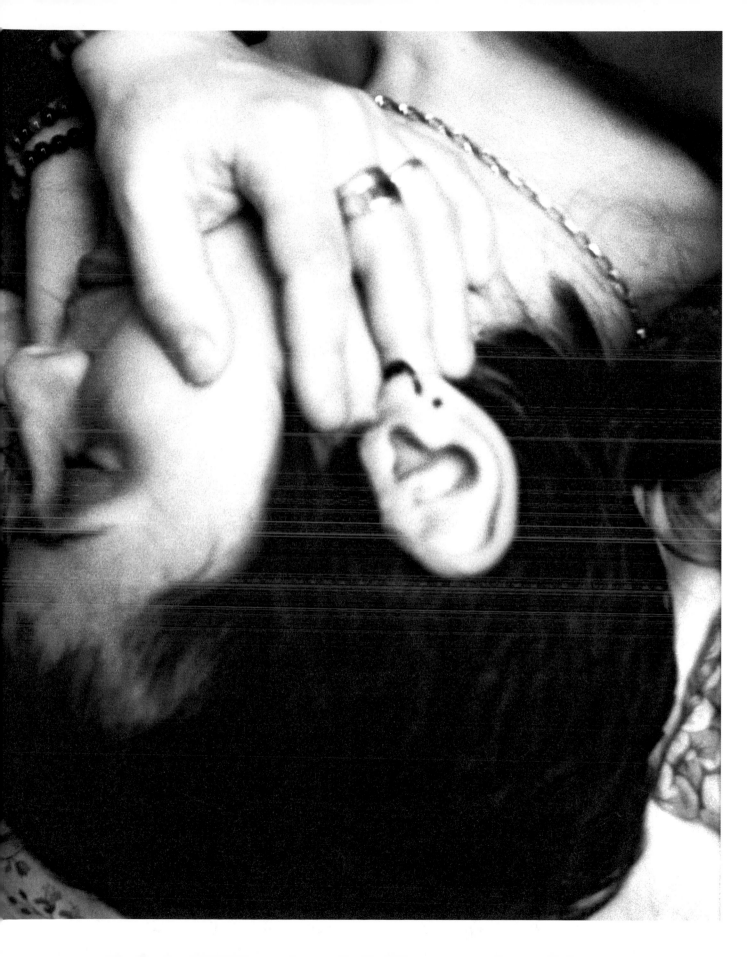

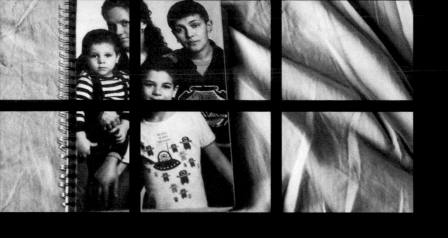
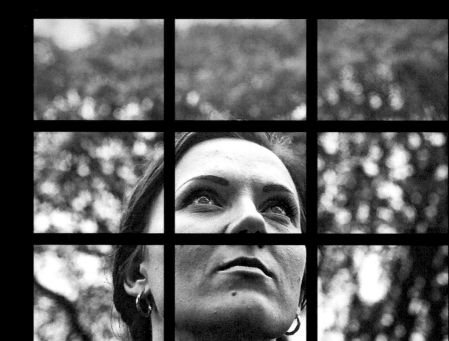

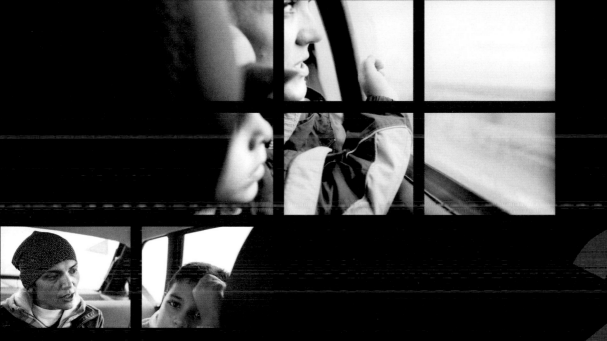

2

ДВА

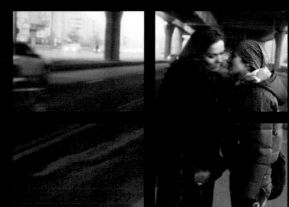

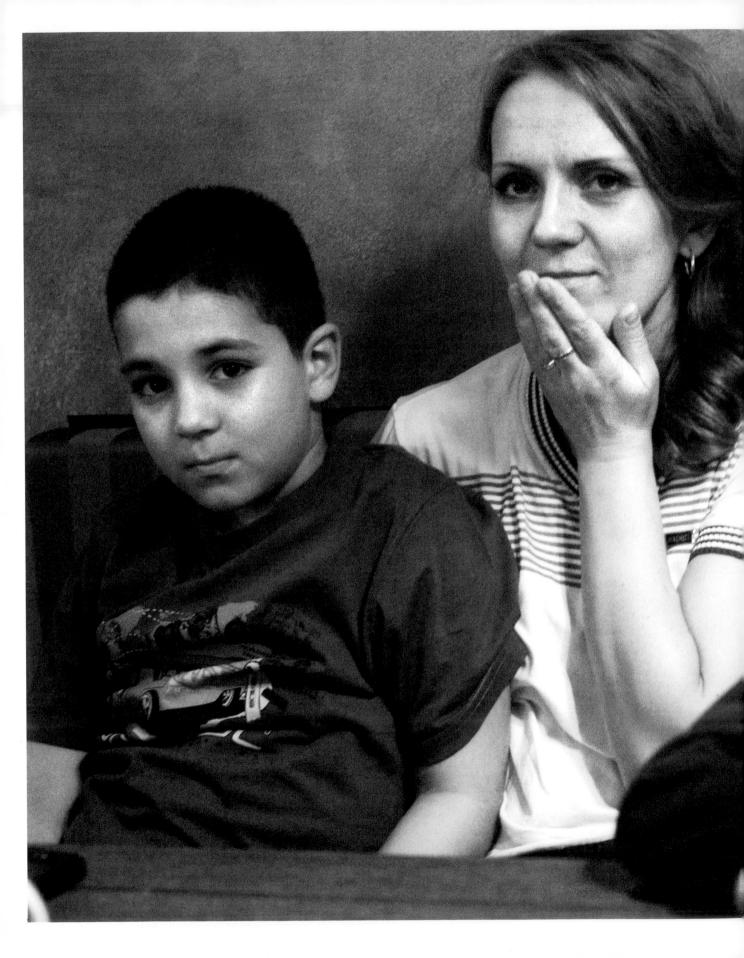

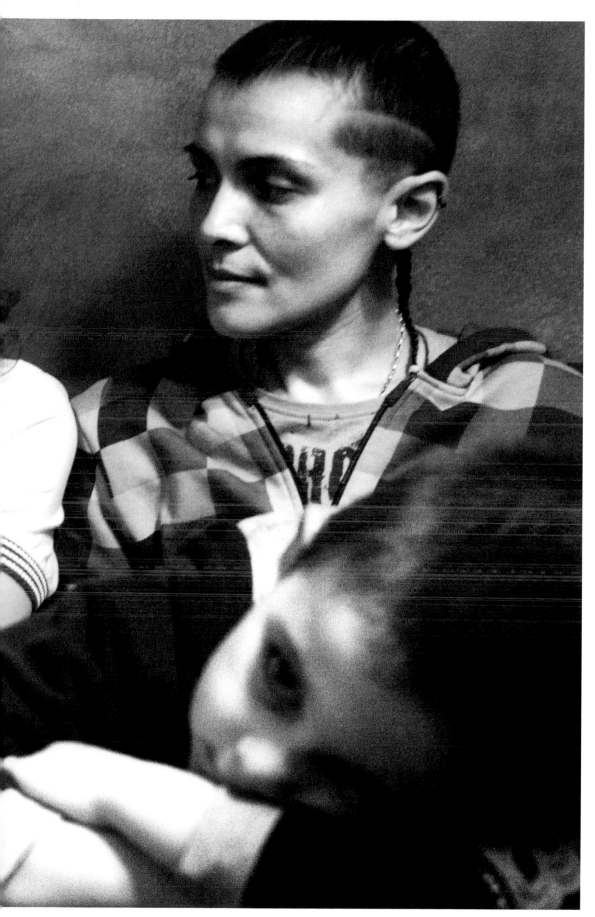

Lyudmila with her two sons and Natasha in a cafe, waiting for their pizza, after spending a Saturday together. Lyudmila separated from her wealthy husband a few years ago but they remain on good terms, and she gets to spend weekends with her children.

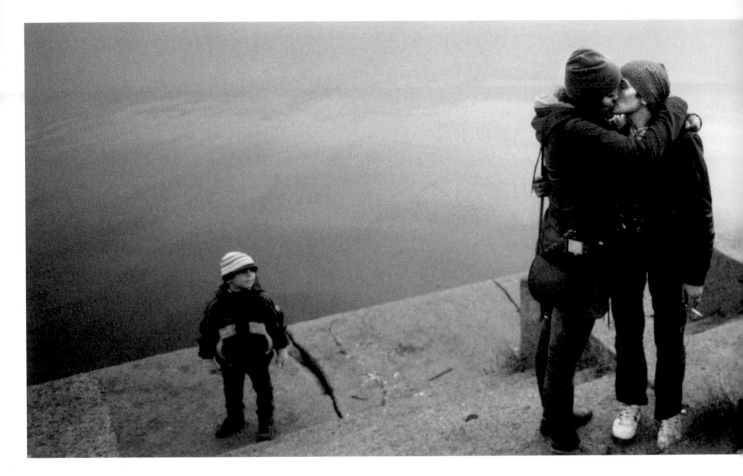

A day trip with Lyudmila's two sons to Kronstadt, a historic city not far from Saint Petersburg.

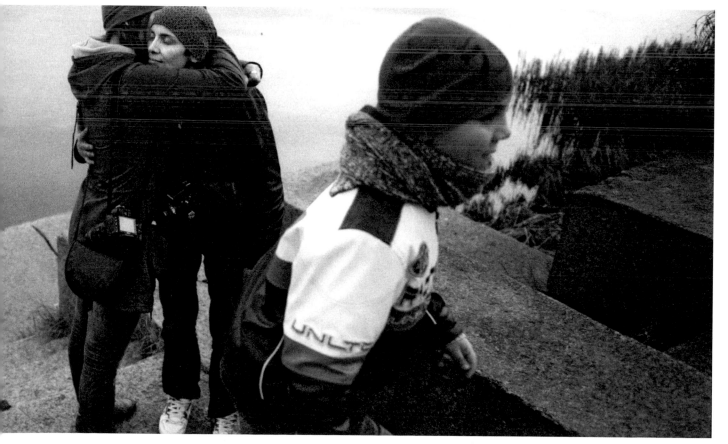

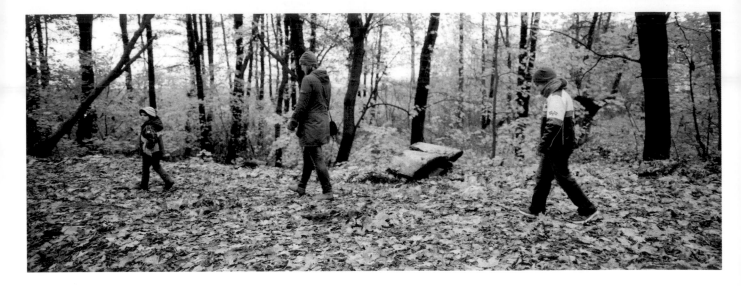

Lyudmila's sons do not think of their mom's lifestyle as unusual, and they accept Natasha as part of their new family. Living in a country of intolerance, they provide a little positive example of tolerance.

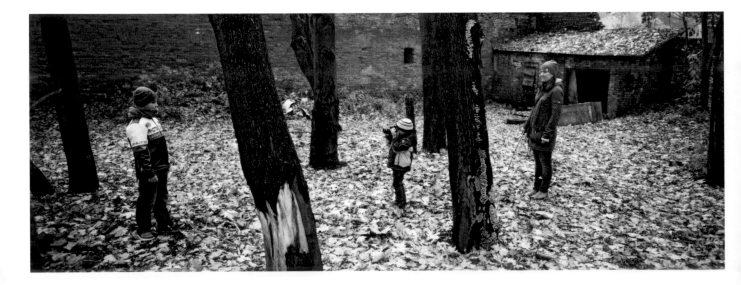

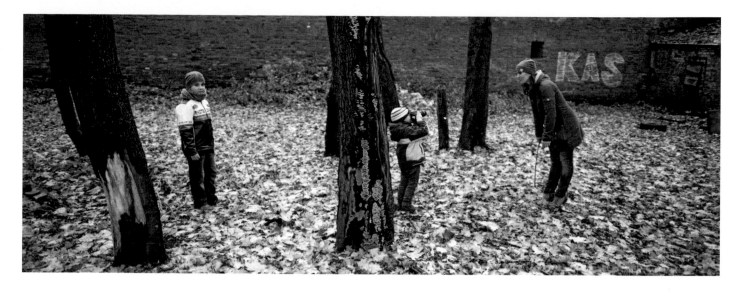

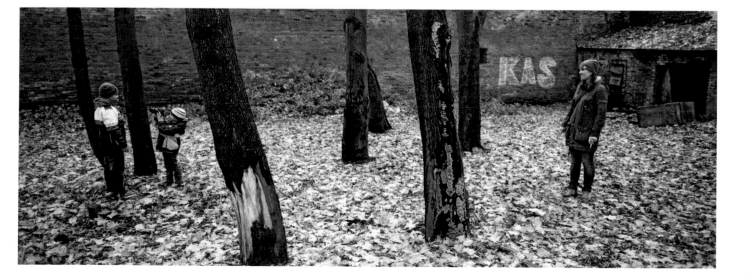

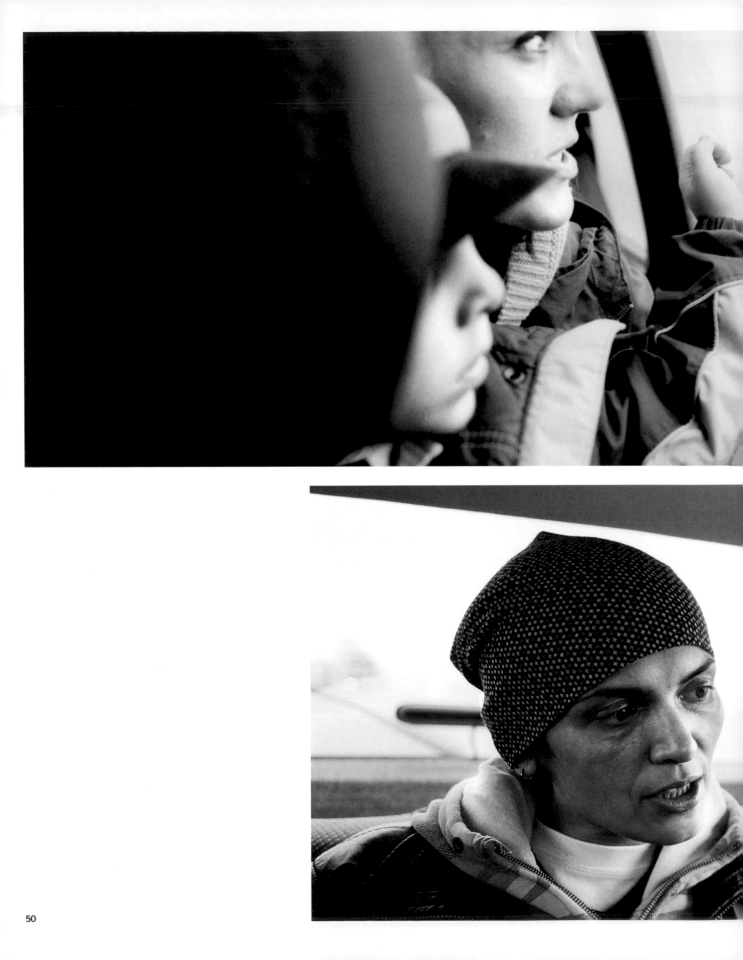

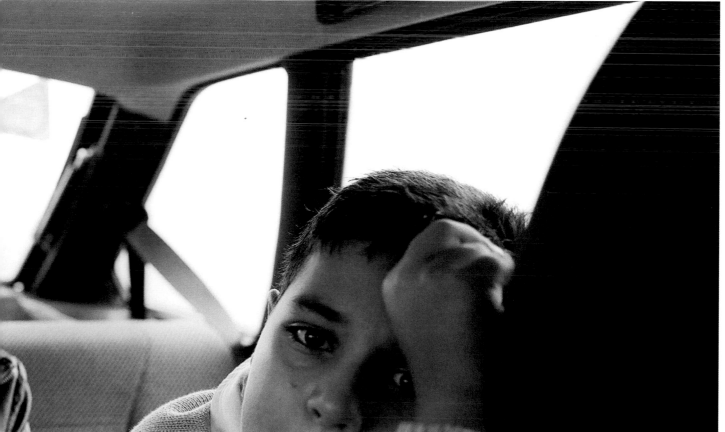

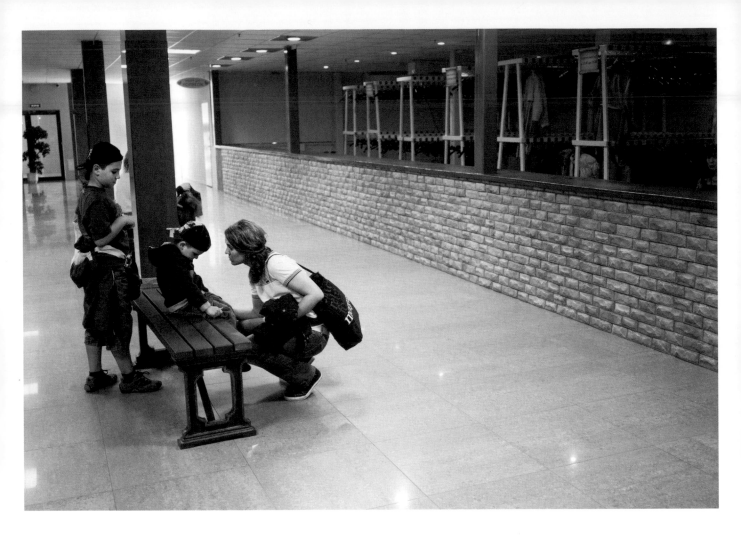

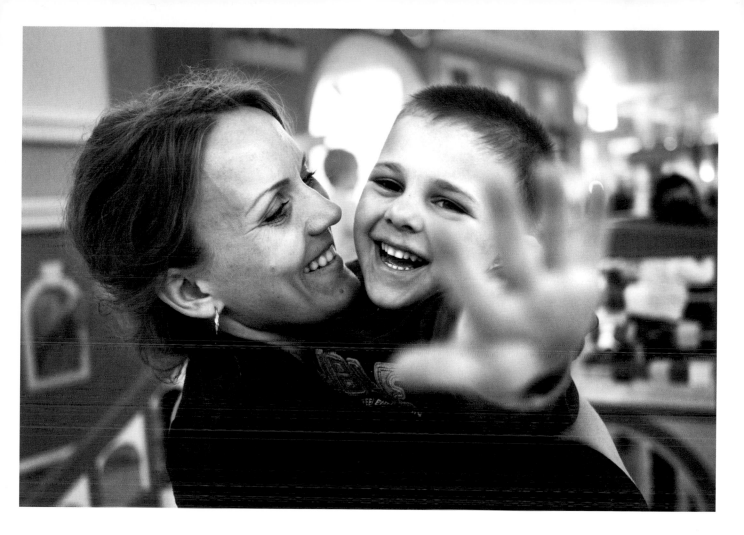

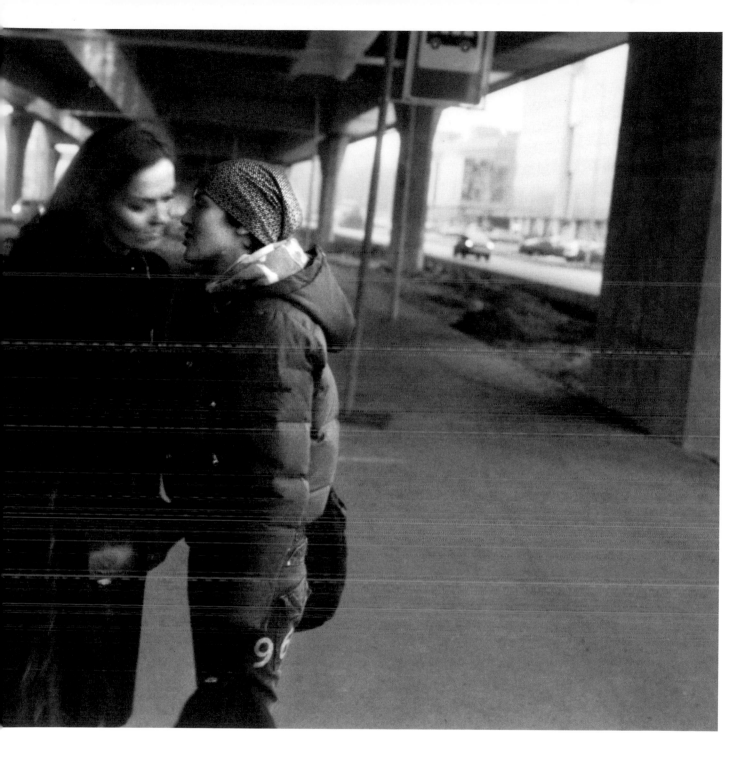

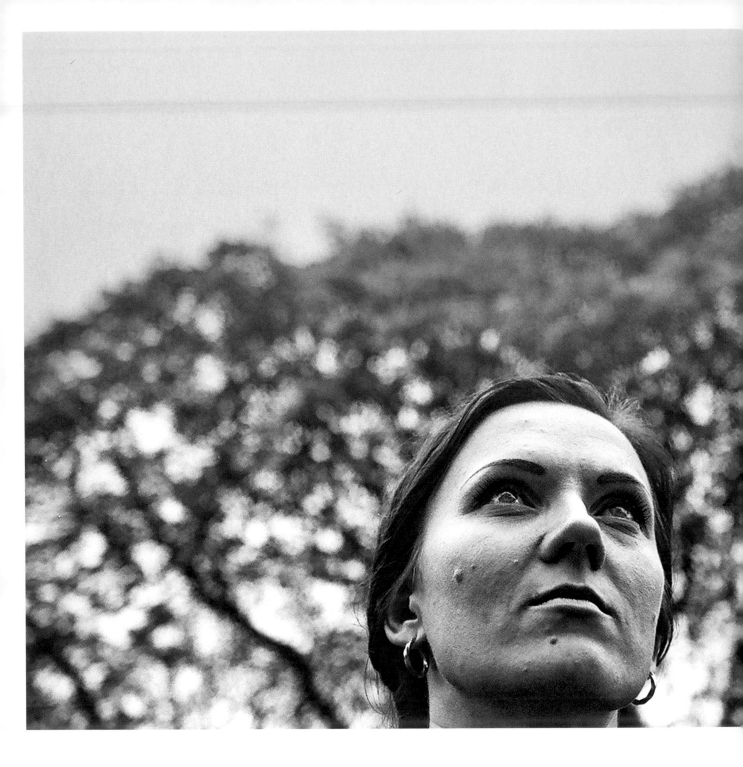

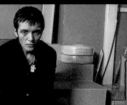
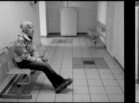
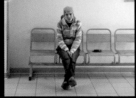

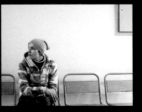

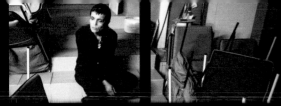

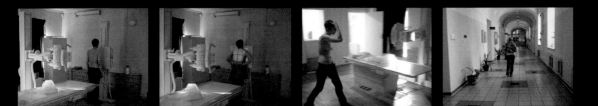

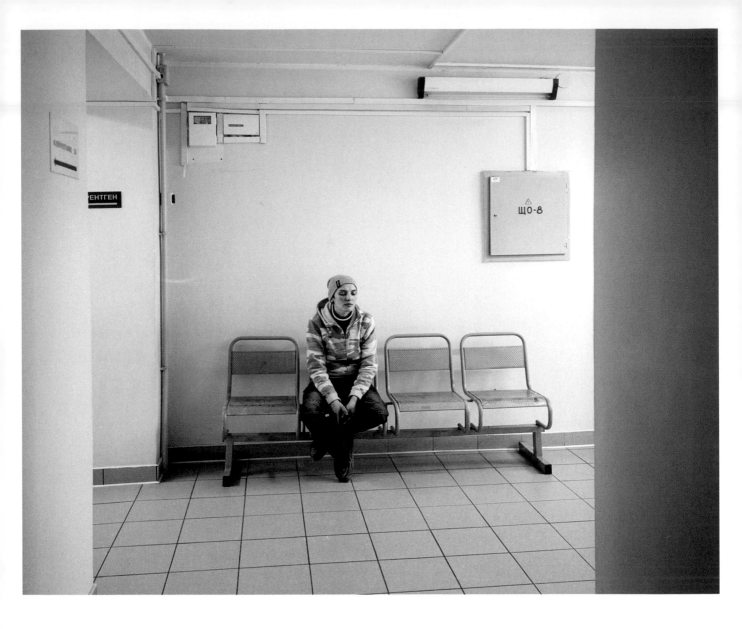

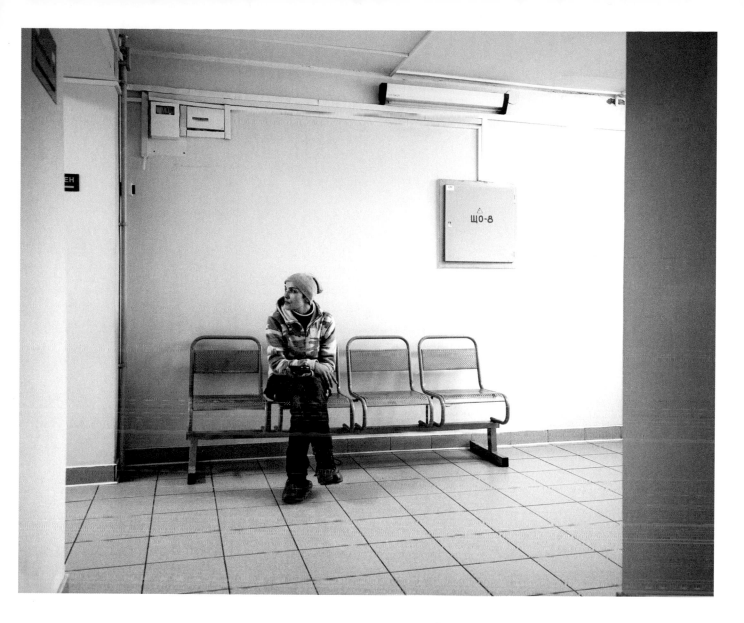

Natasha waiting in a hospital for a doctor, for a chest x ray to check whether she has tuberculosis. Tuberculosis is epidemic in Russia.

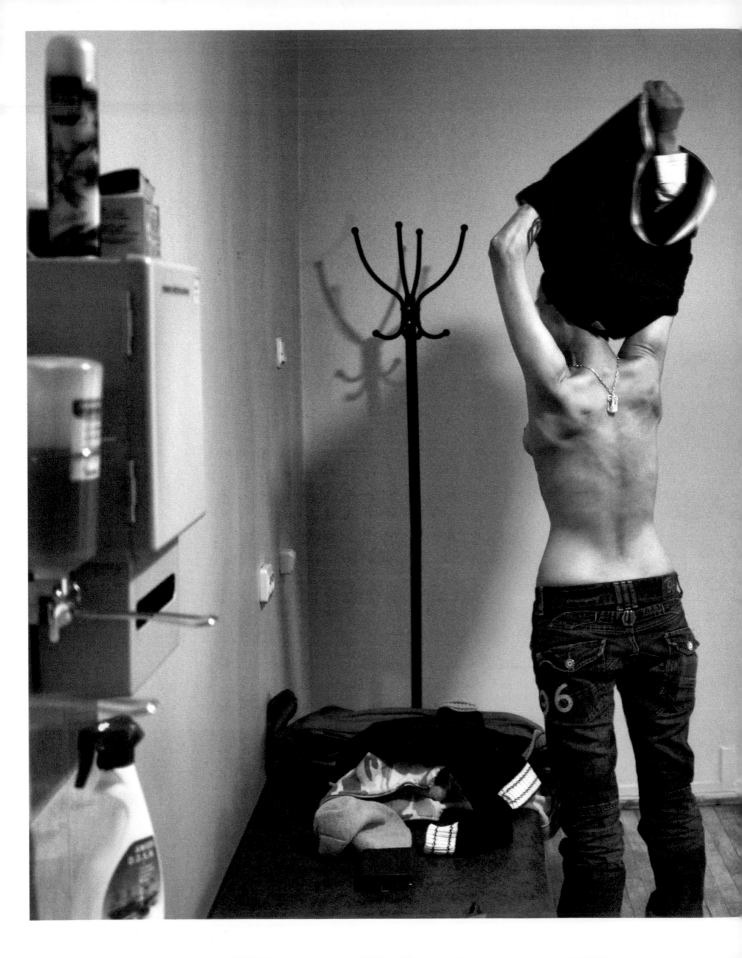

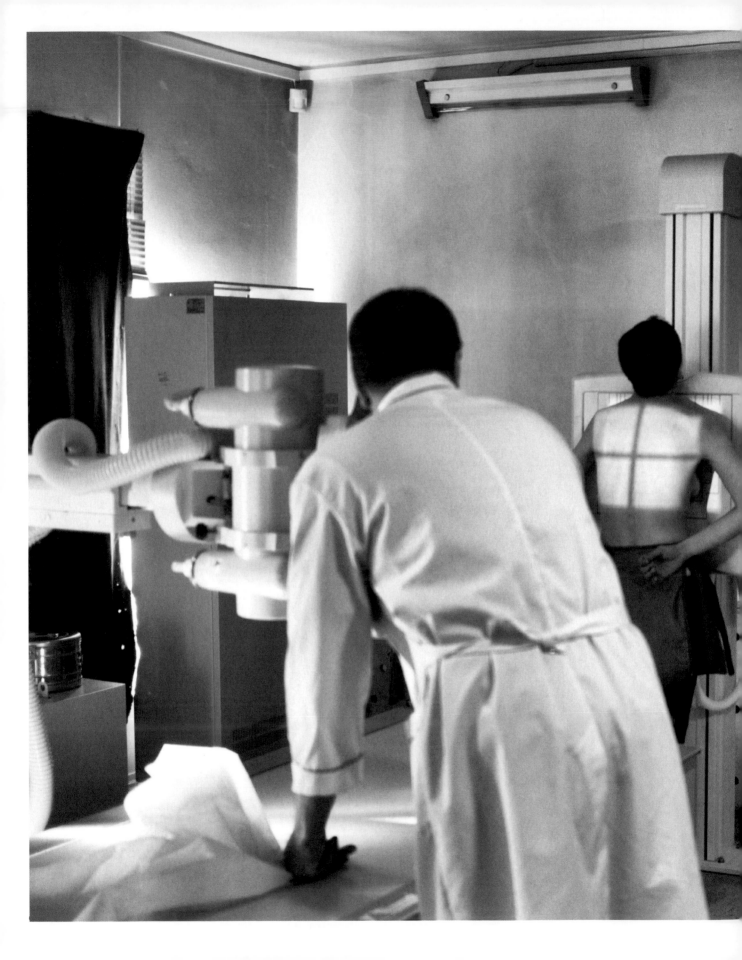

Natasha getting her chest x-rays.

Natasha in tears, remembering her past.

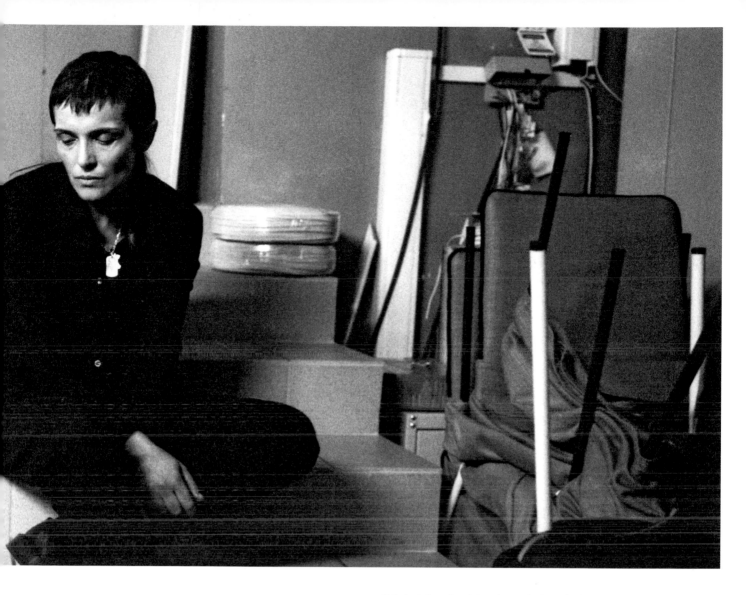

Natasha takes a break from her work at a nightclub, where she takes photographs of partygoers. During the day, she studies photography in a local art school.

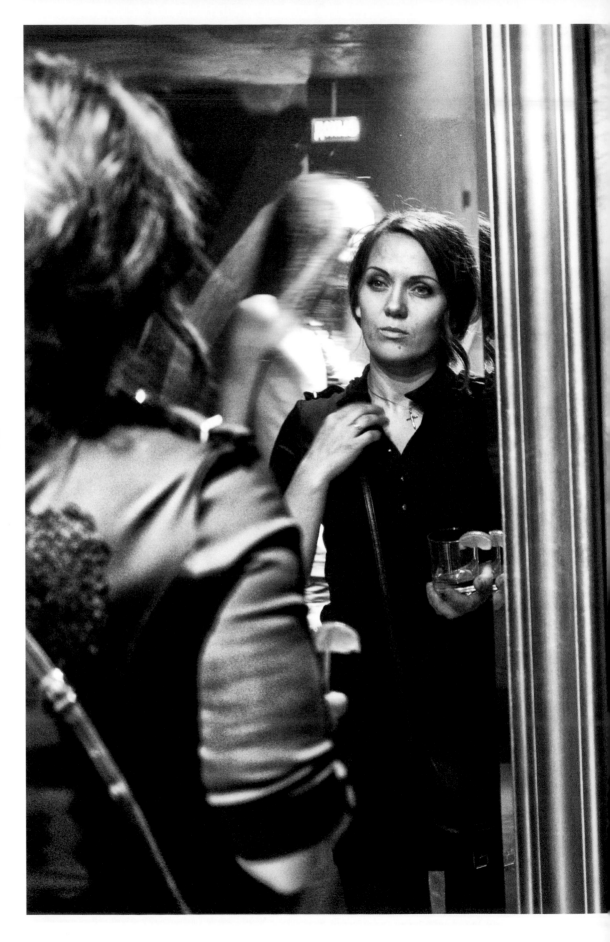

Lyudmila checking herself in a mirror backstage in a nightclub while Natasha looks on. For the most part, Lyudmila only goes to clubs when Natasha is working there, taking photographs of patrons.

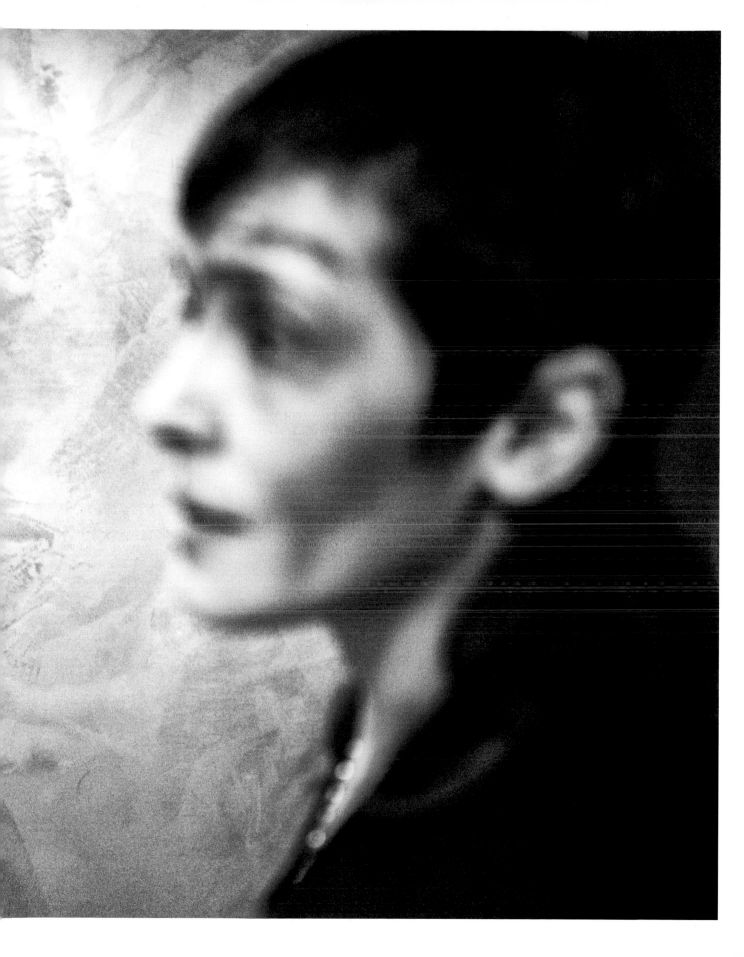

Natasha and Lyudmila at a nightclub, at a closed "girls only" party. Although there are several gay clubs in Saint Petersburg, most of the LGBT nightlife revolves around private parties, announced only online, or advertised by word-of-mouth. There are almost nightly protests by religious zealots outside gay clubs, and private parties provide much-needed safety for those who want to go out.

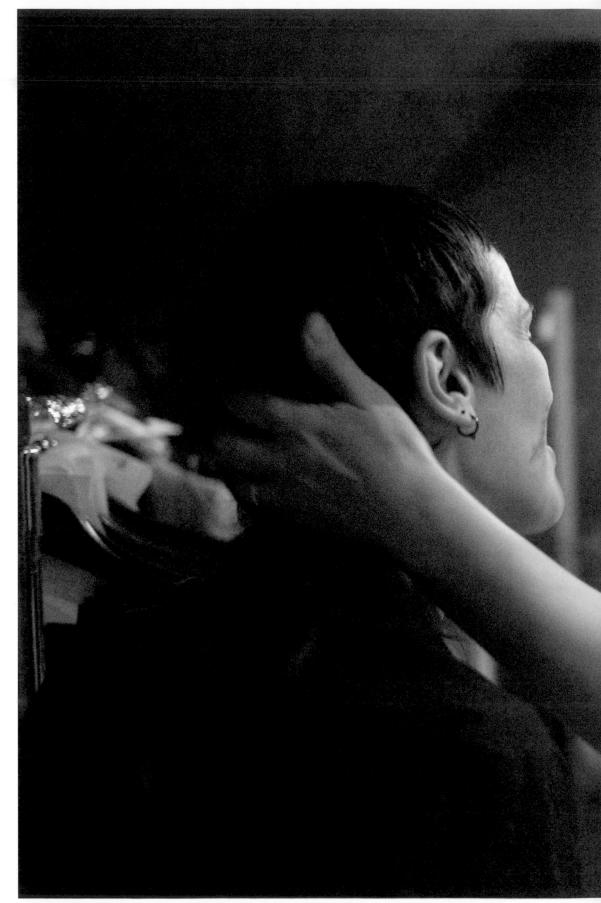

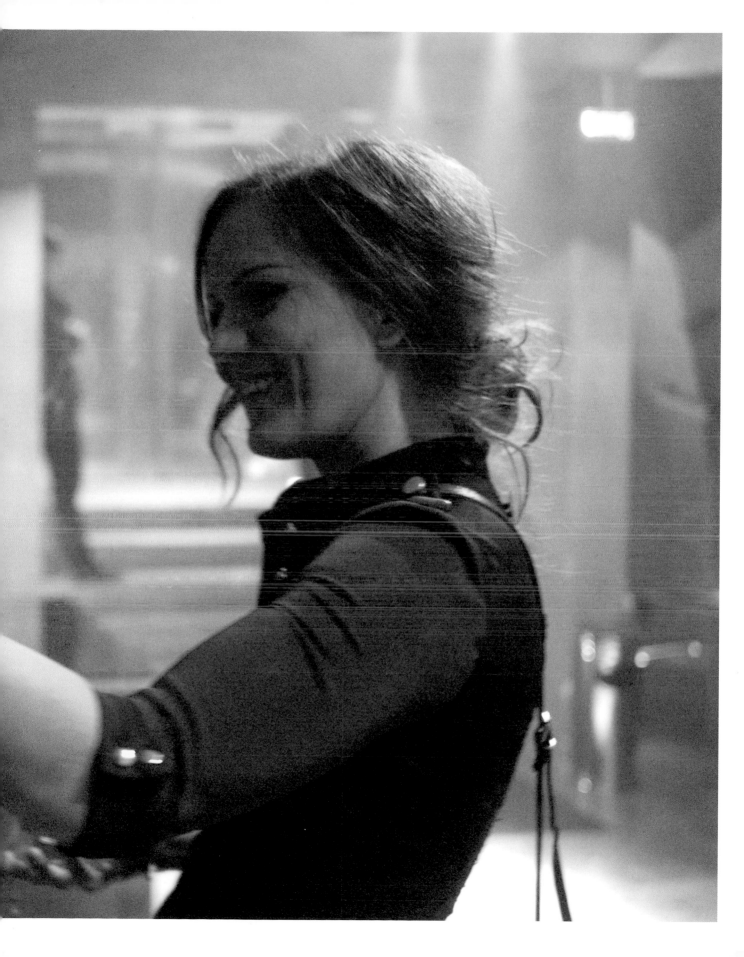

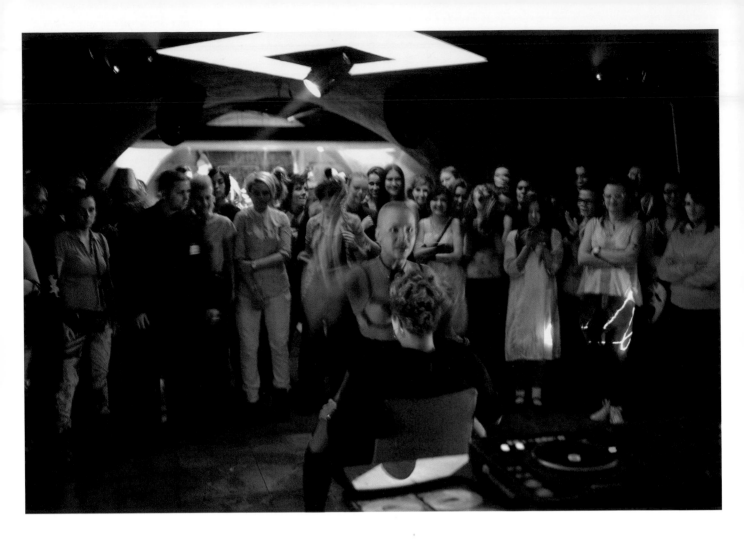

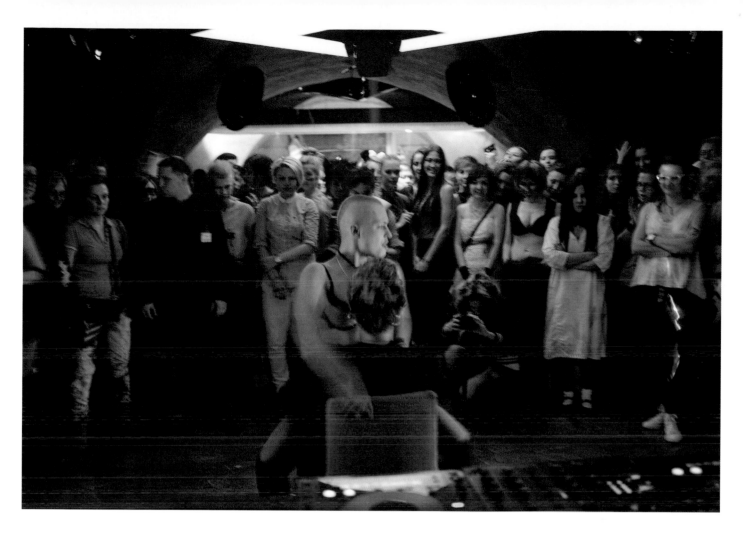

Natasha and Lyudmila at a striptease in a nightclub.

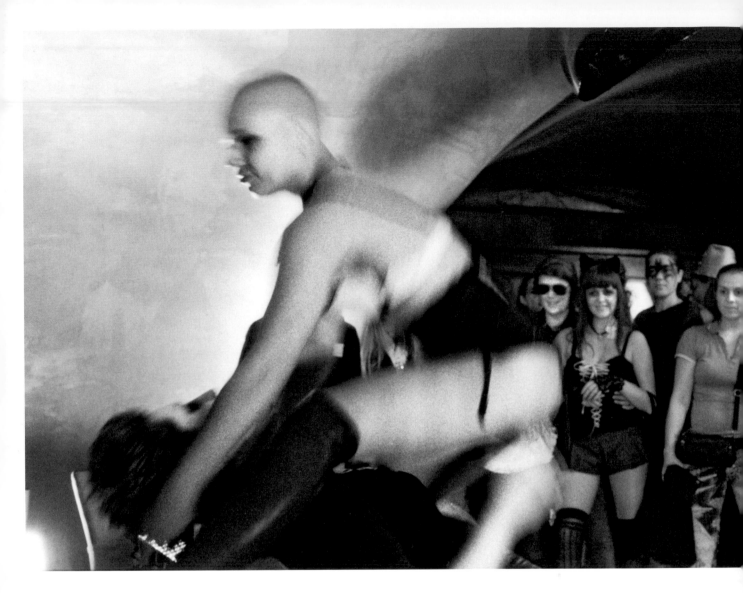

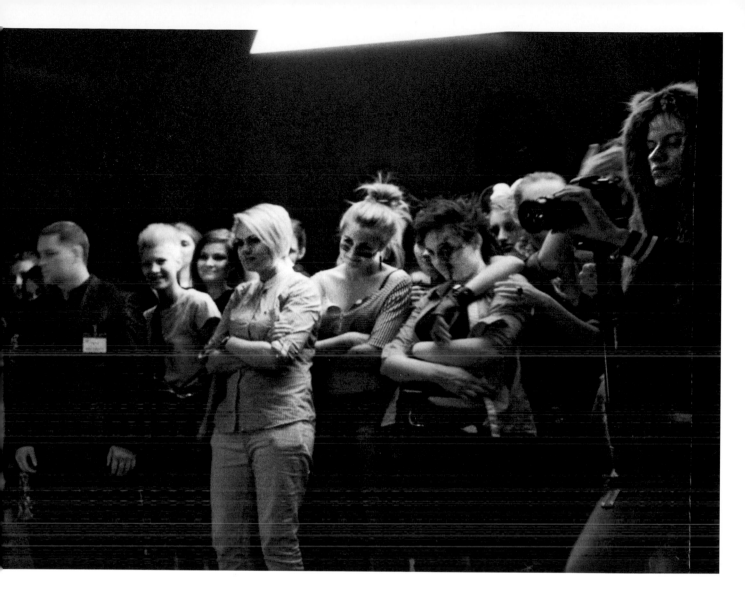

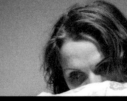

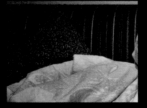

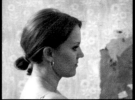

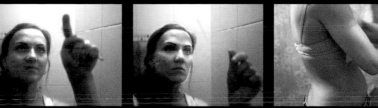

4

ЧЕТЫРЕ

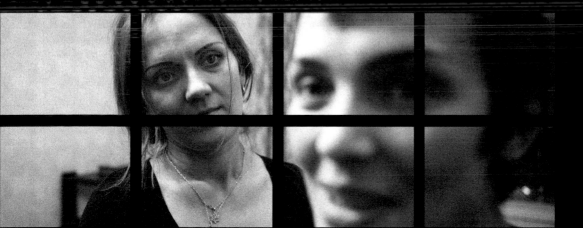

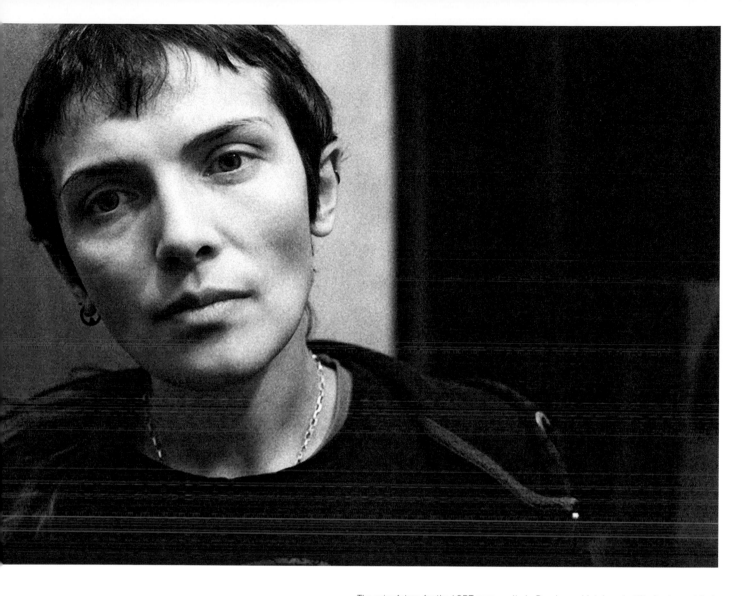

The grim future for the LGBT community in Russia, and intolerant attitudes toward their relationship, adds an extra level of stress to Lyudmila and Natasha's daily lives together. Lyudmila and Natasha regularly fight and have broken up on several occasions. Still, they both believe that their lives are incomplete without each other.

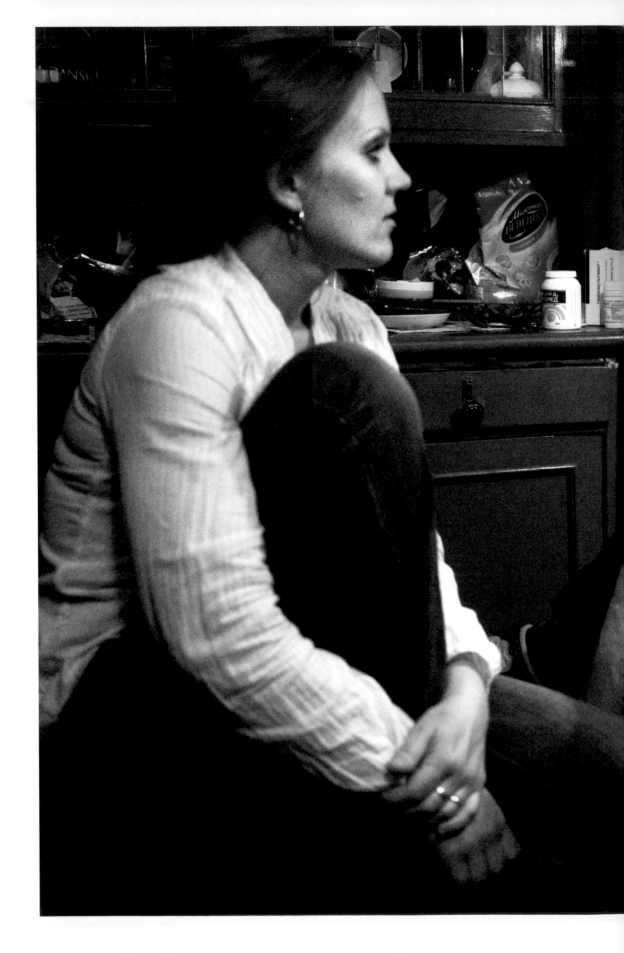

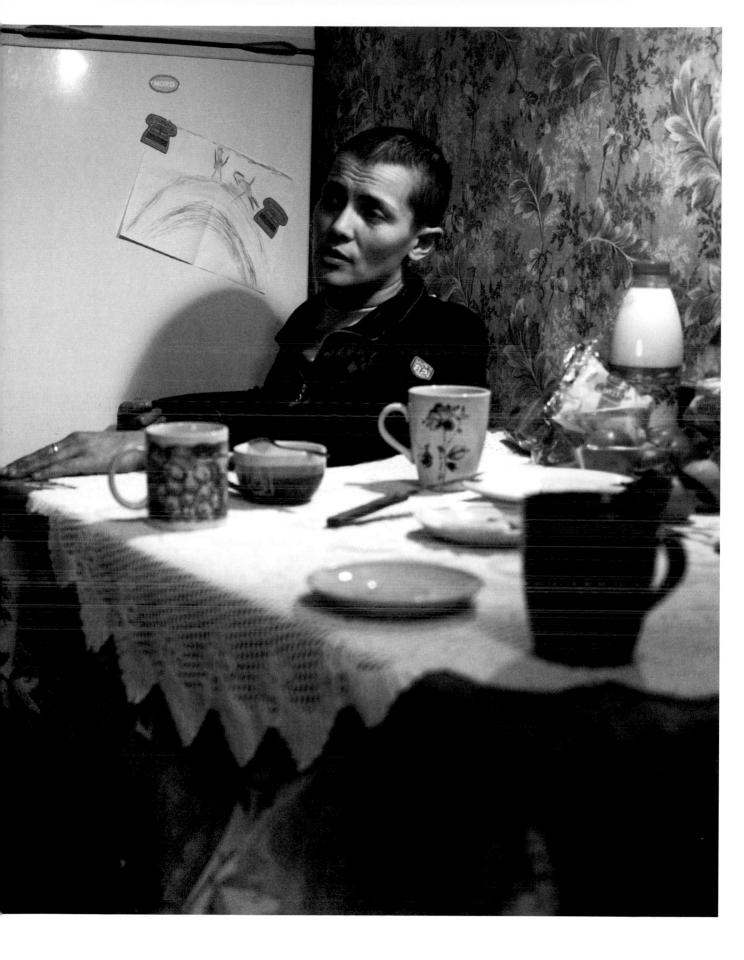

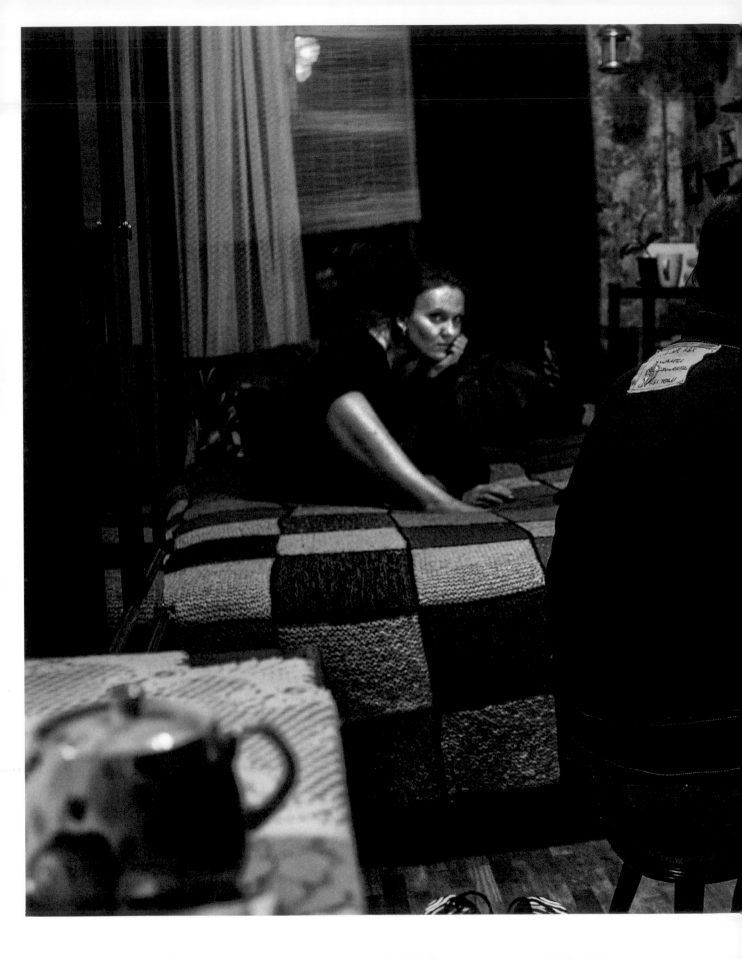

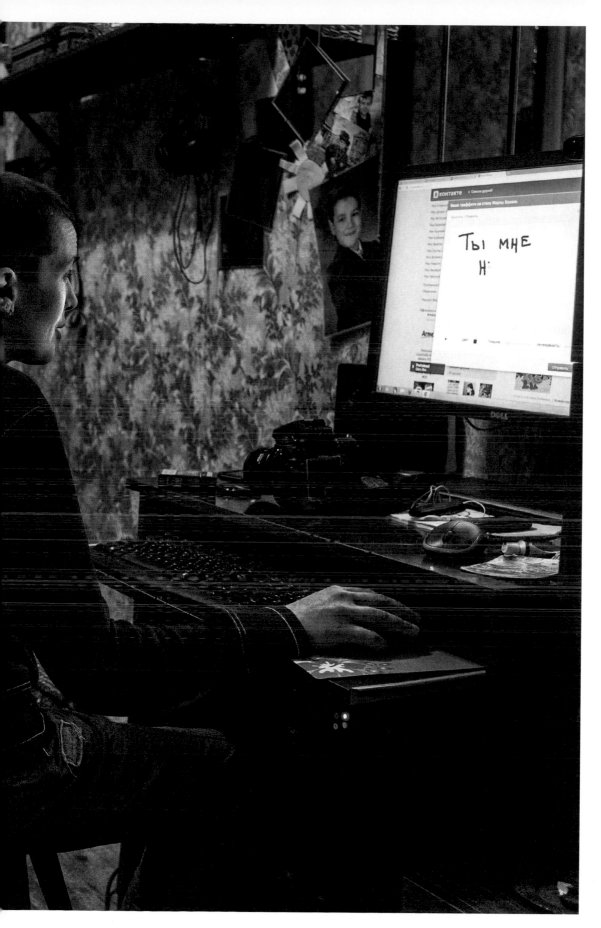

Lyudmila watches as Natasha surfs the web in their room in a communal apartment. Most of the communications among the quite populous Russian LGBT community happen online, in closed groups on social networks, or in anonymous chat rooms. In these online communities it is possible to find a new job, a party to go to, or a new love.

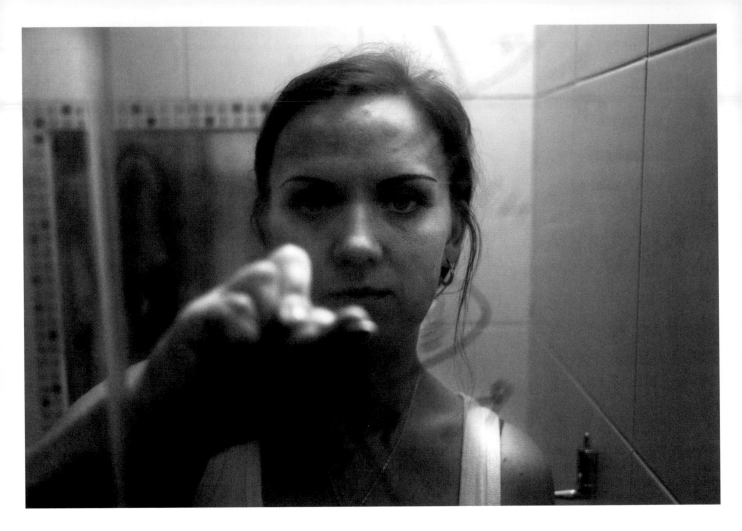

During one of their fights, Lyudmila draws with lipstick on a bathroom mirror.

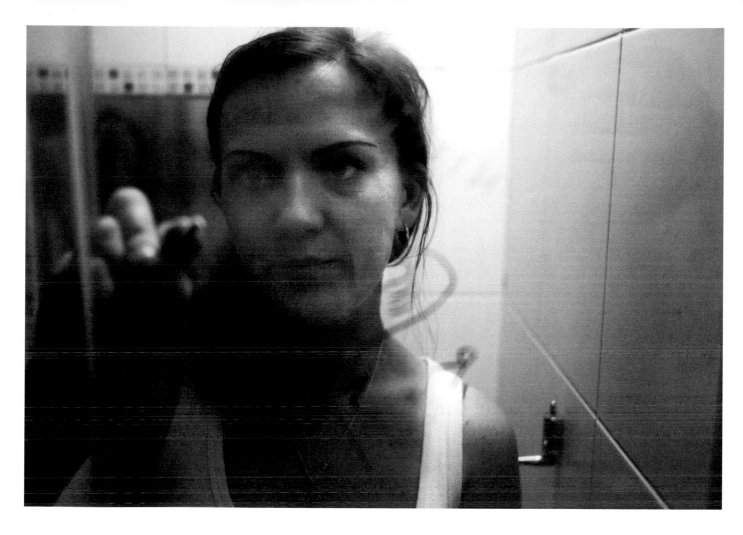

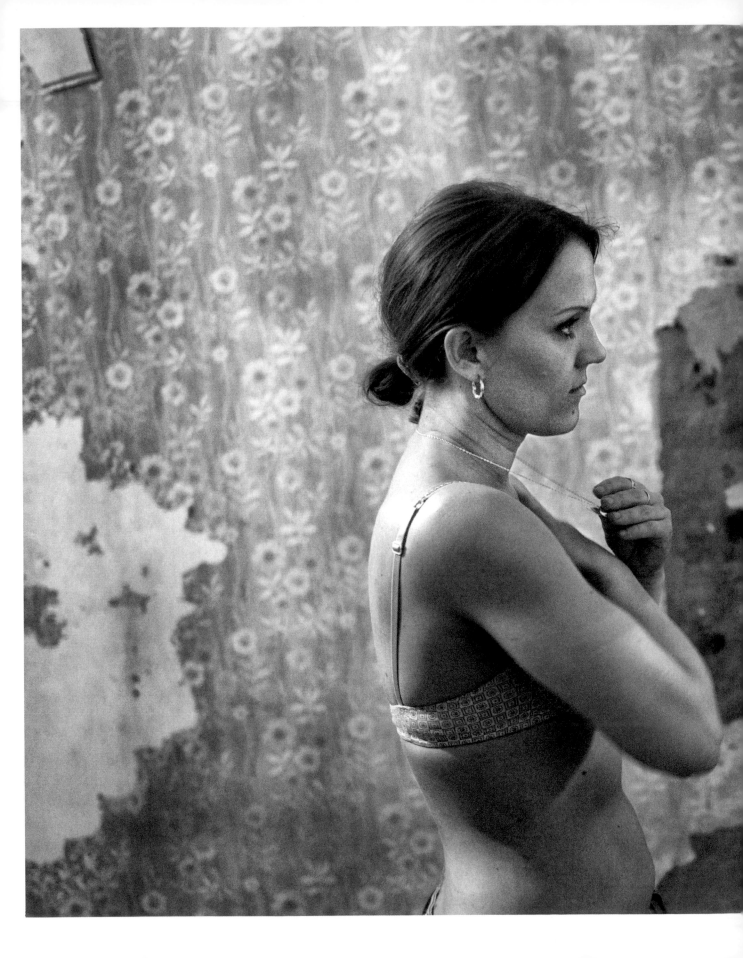

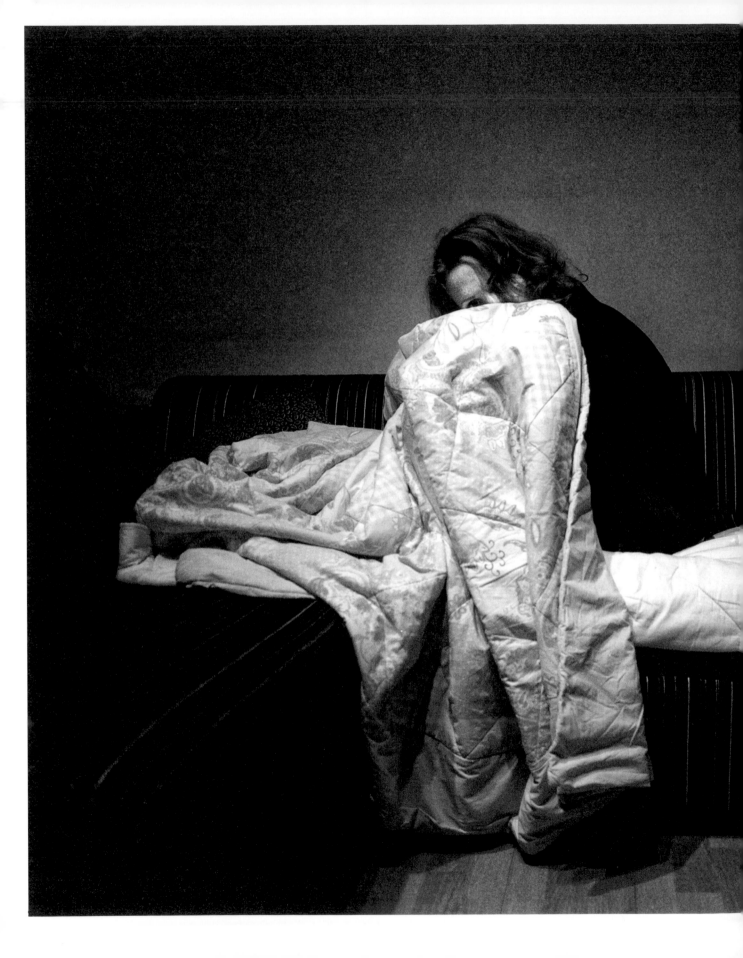

Lyudmila sleeping on a couch in her ex-husband's apartment, where she moved after a fight with Natasha.

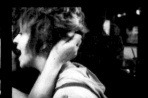
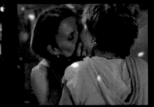
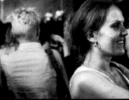

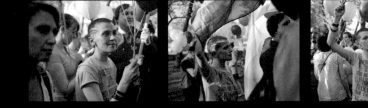

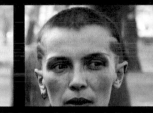

ПЯТЬ

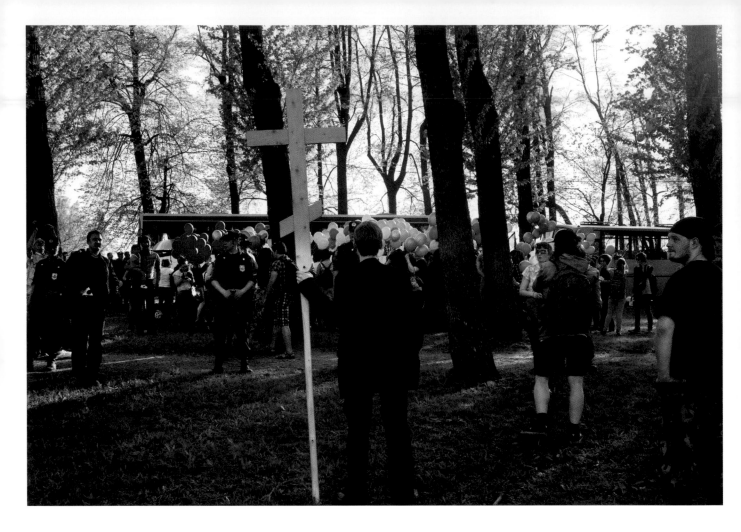

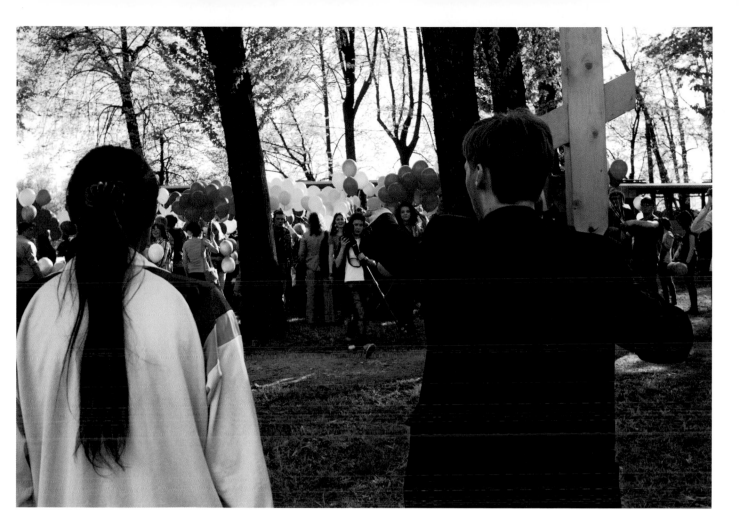

In a rare decision, Natasha participates in an LGBT event: the release of rainbow colored balloons. The event was sanctioned by city authorities, though "in order to protect participants from angry citizens," it was held in a remote corner of one of Saint Petersburg's parks. Numerous policemen were there to protect LGBT activists from angry religious zealots holding crosses and shouting insults

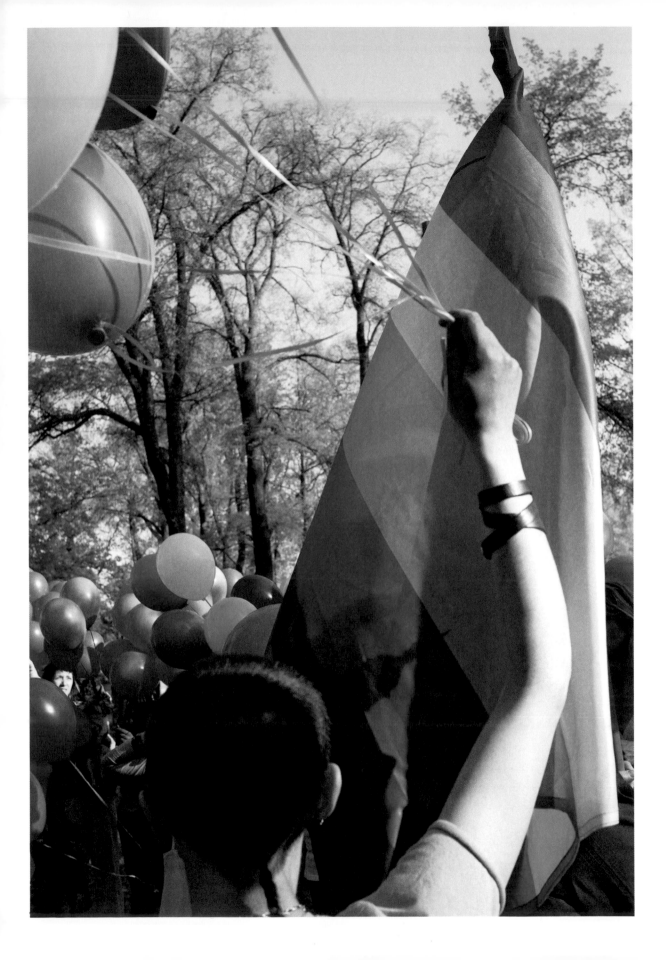

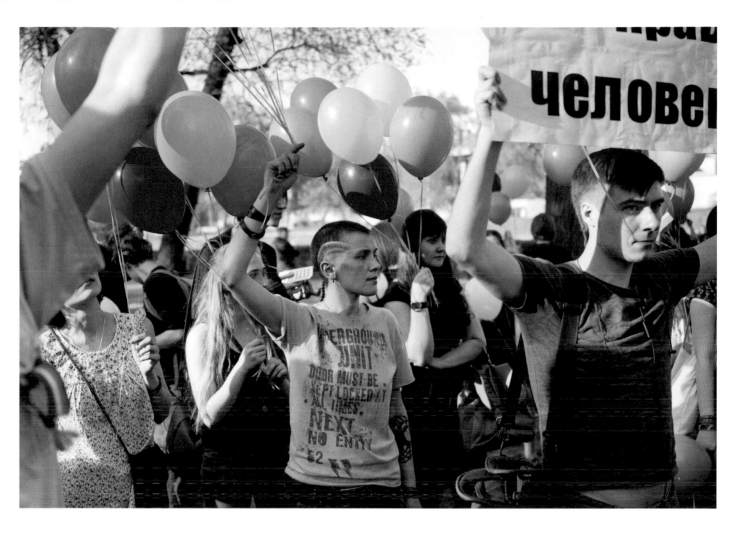

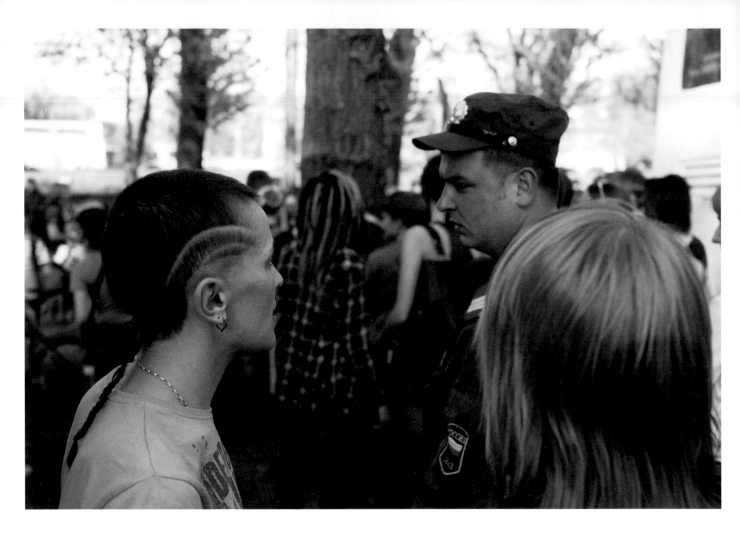

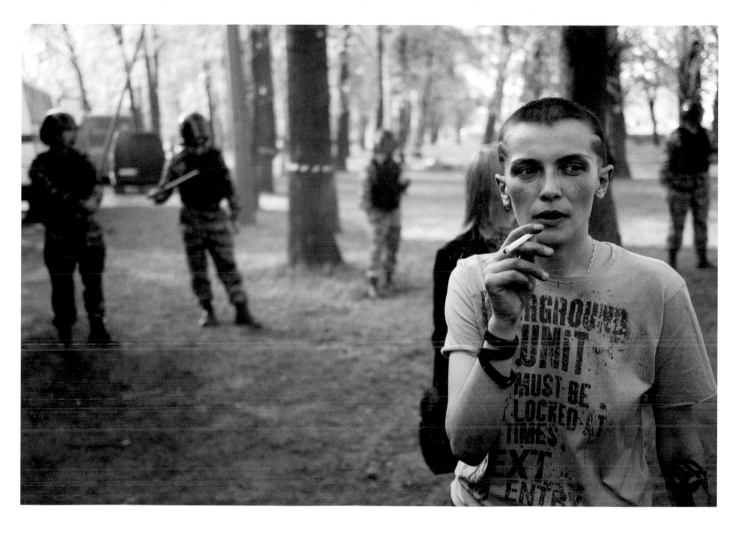

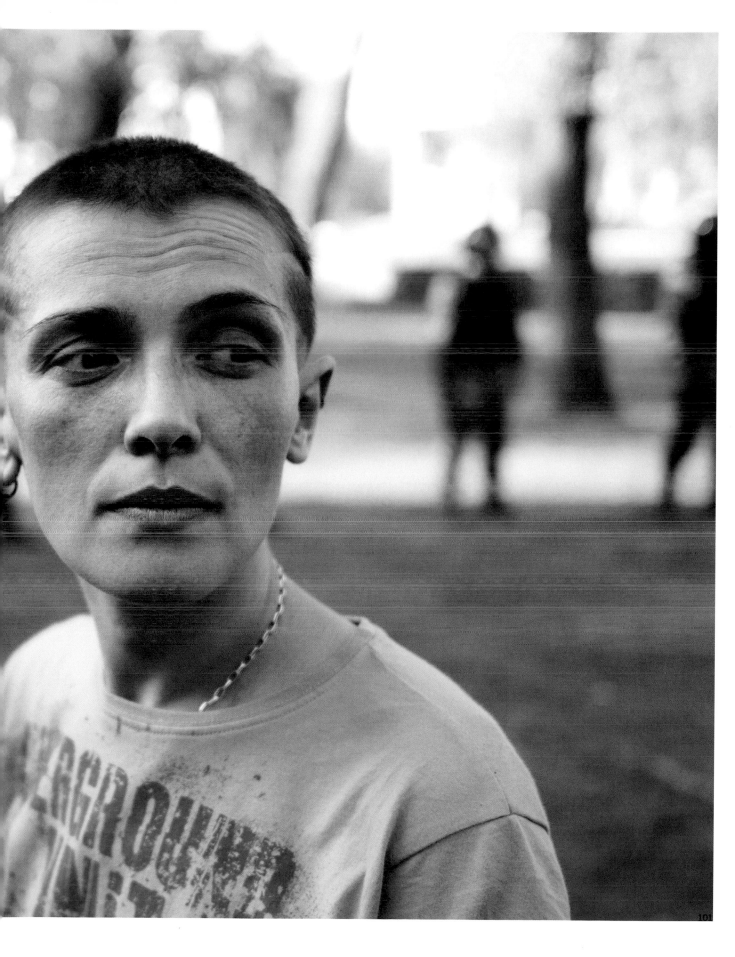

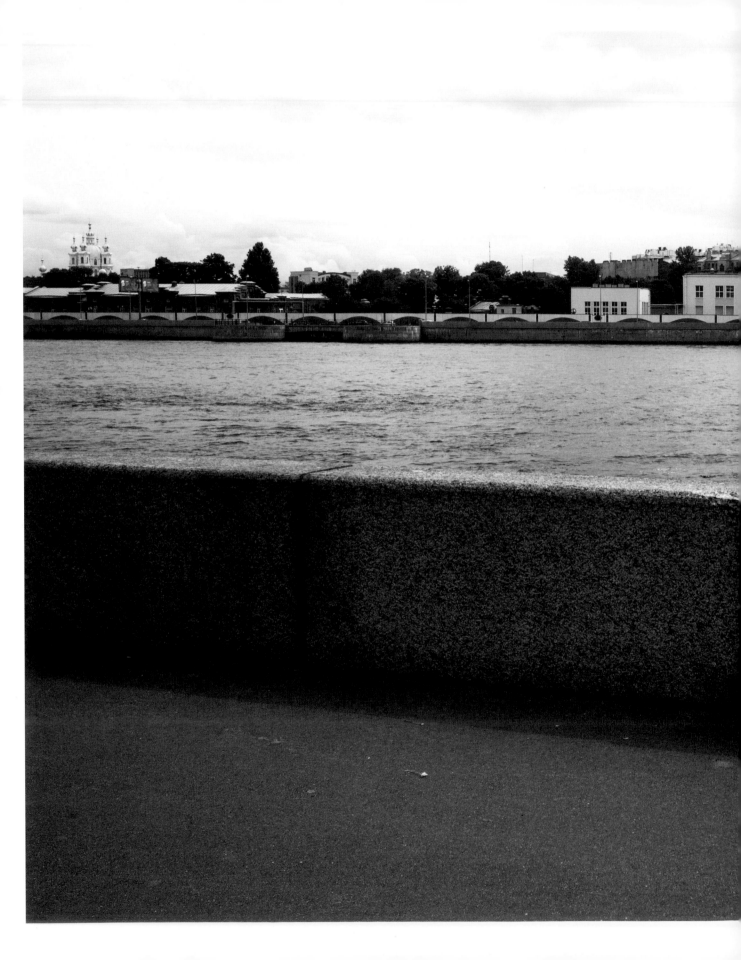

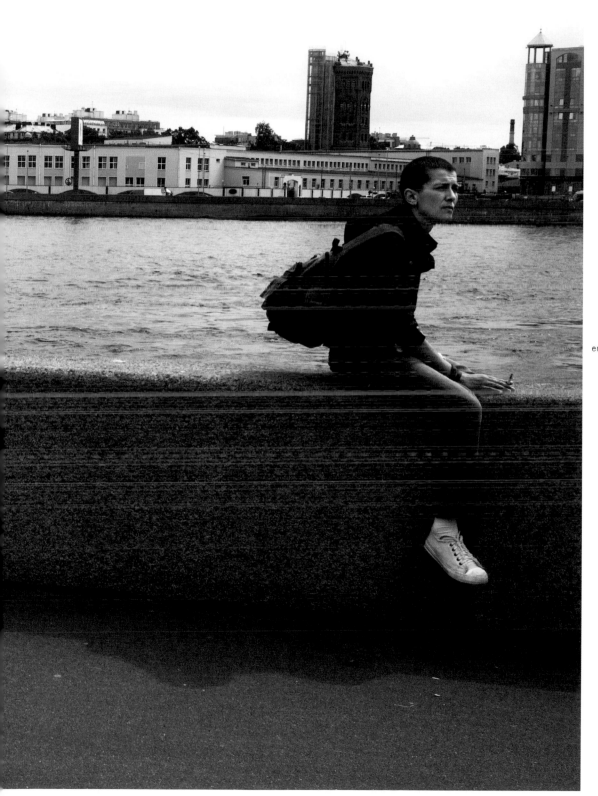

Natasha sitting on an embankment of the Neva River, after her split from Lyudmila.

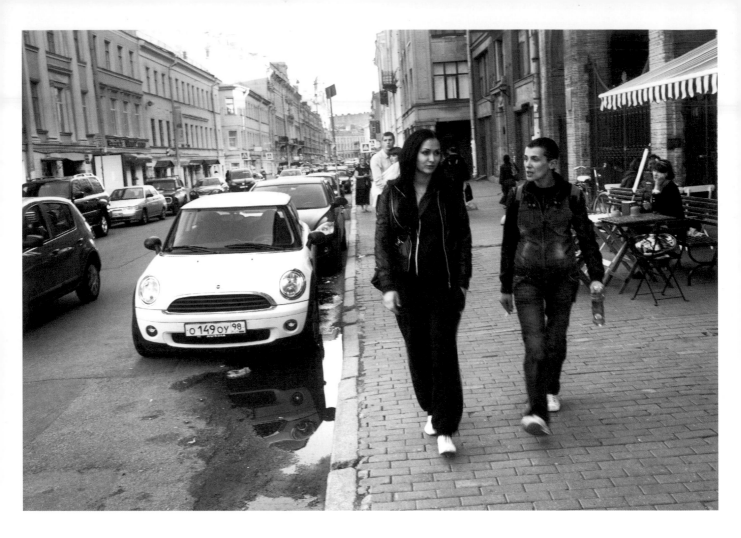

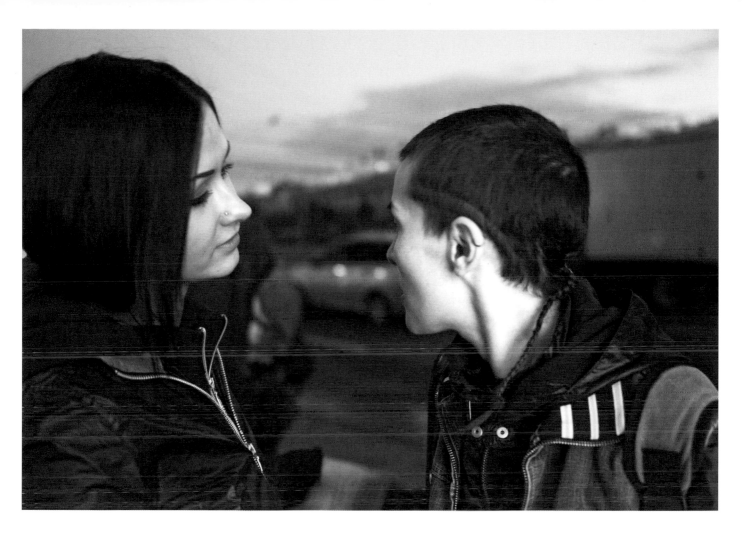

Natasha on a date in the city with her new girlfriend.

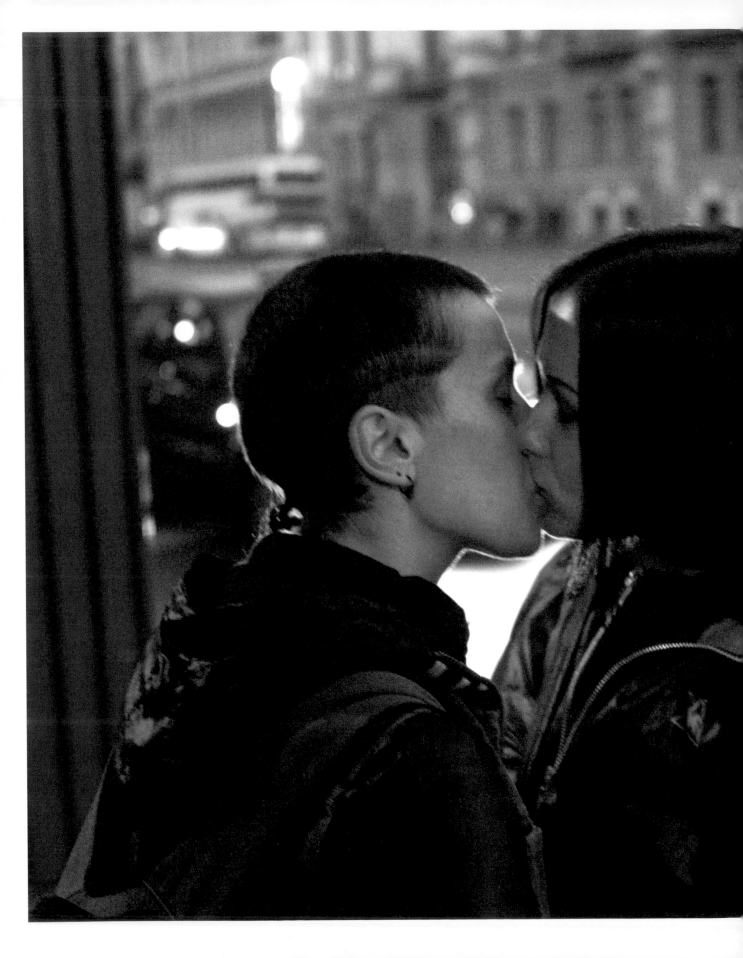

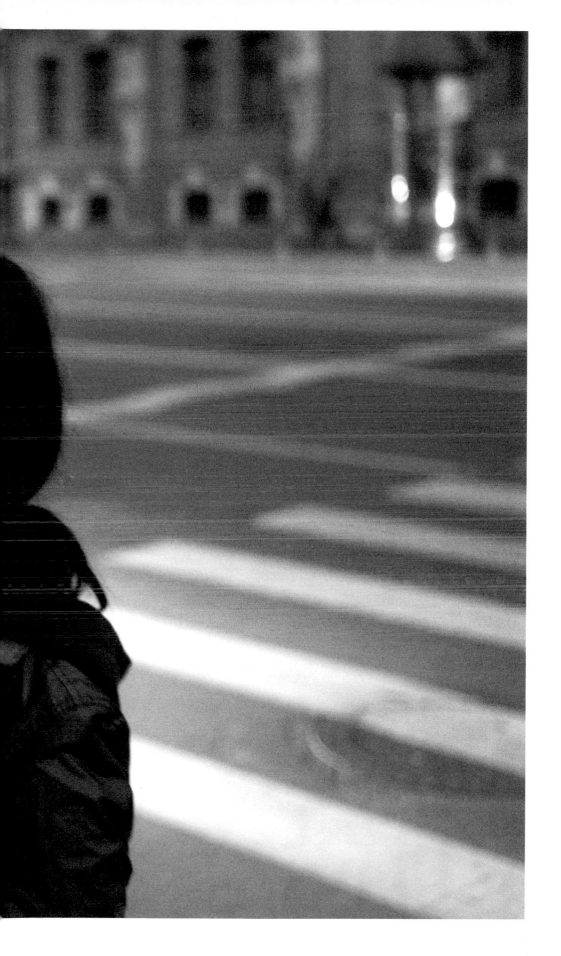

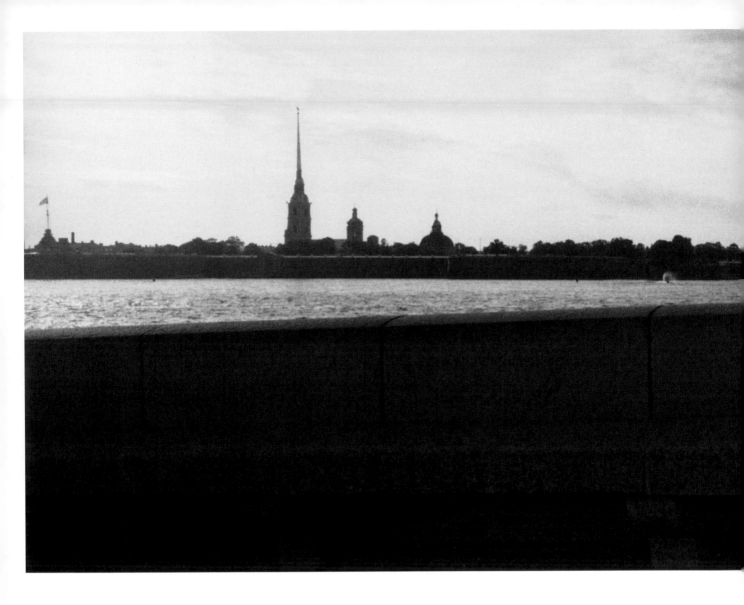

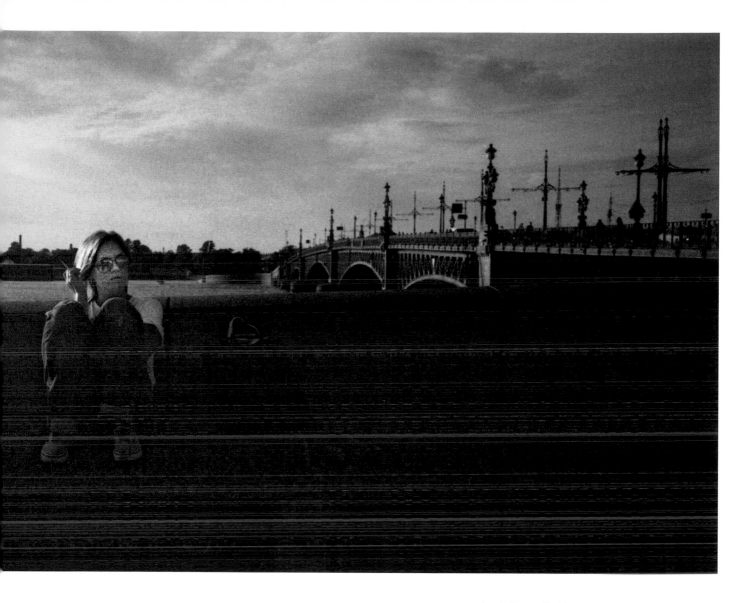

Lyudmila near the Hermitage, on the Neva embankment.

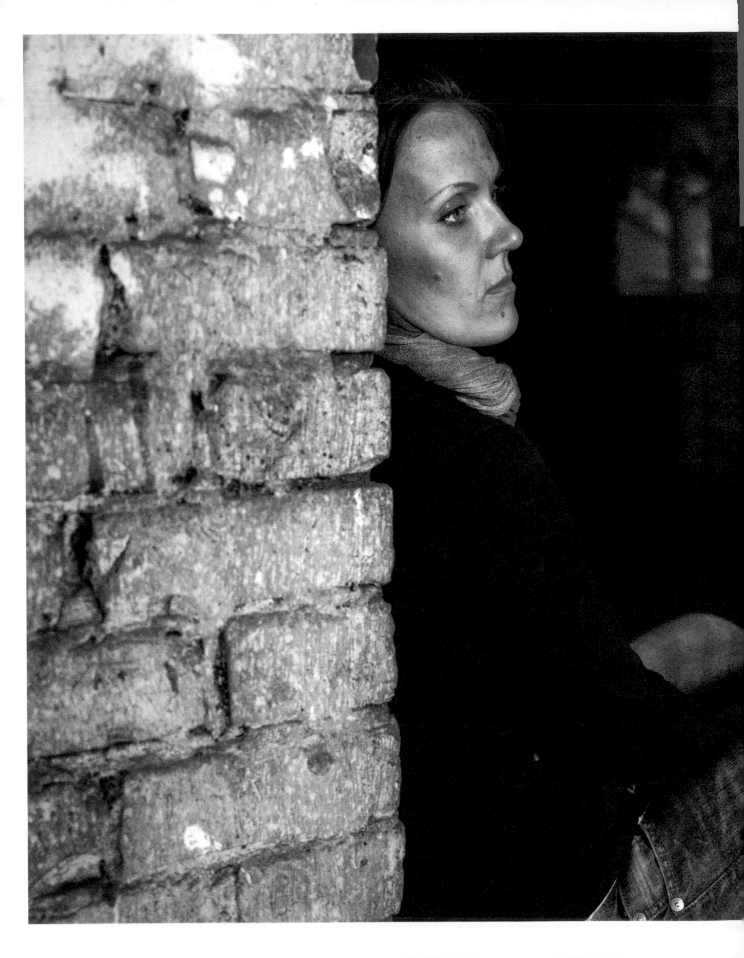

Lyudmila, after her split
from Natasha.

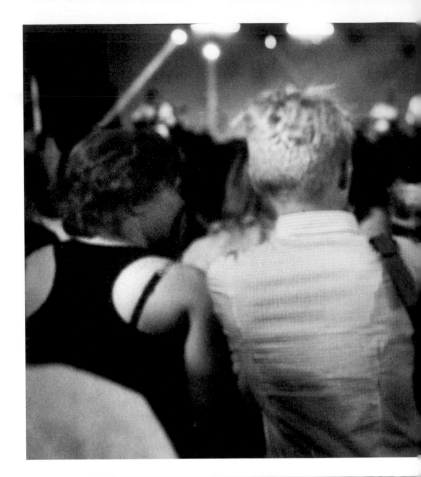

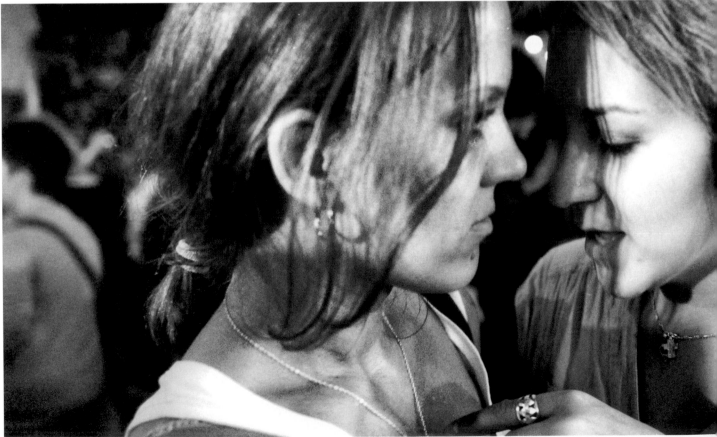

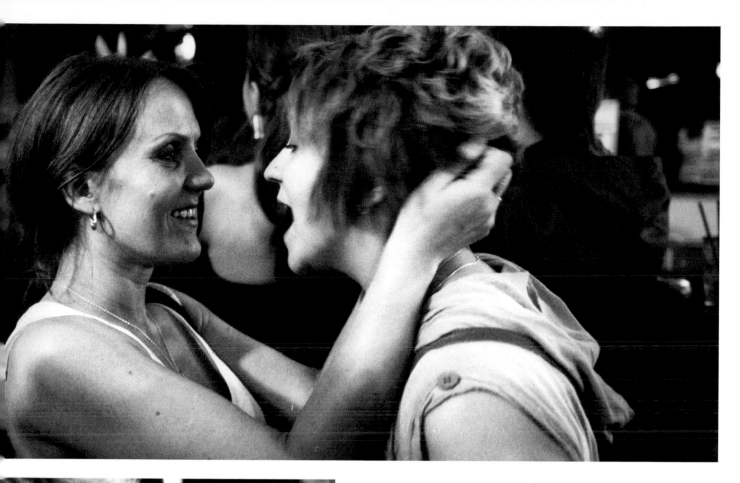

Lyudmila partying with her new girlfriend Inga.

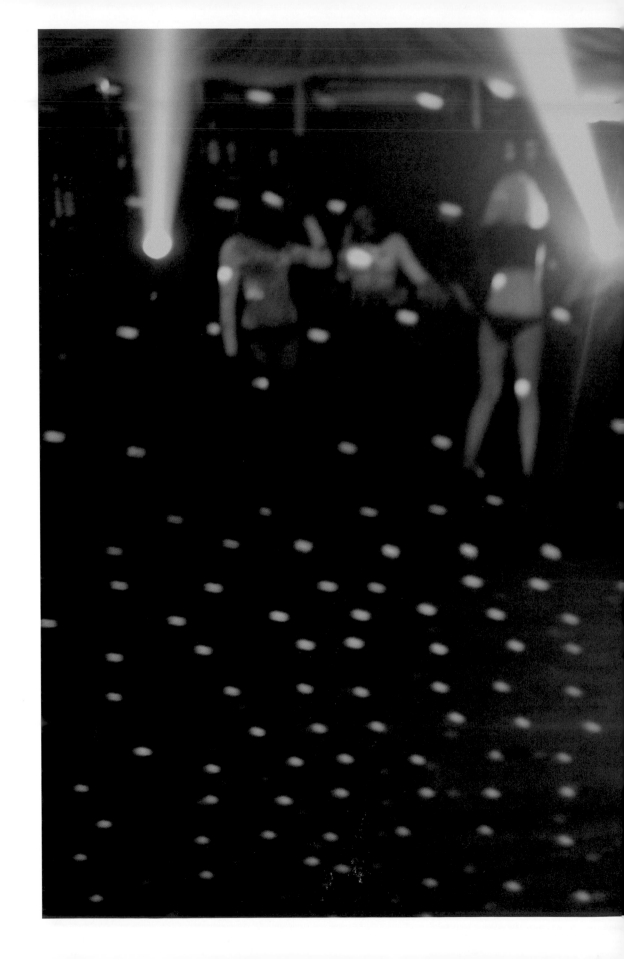

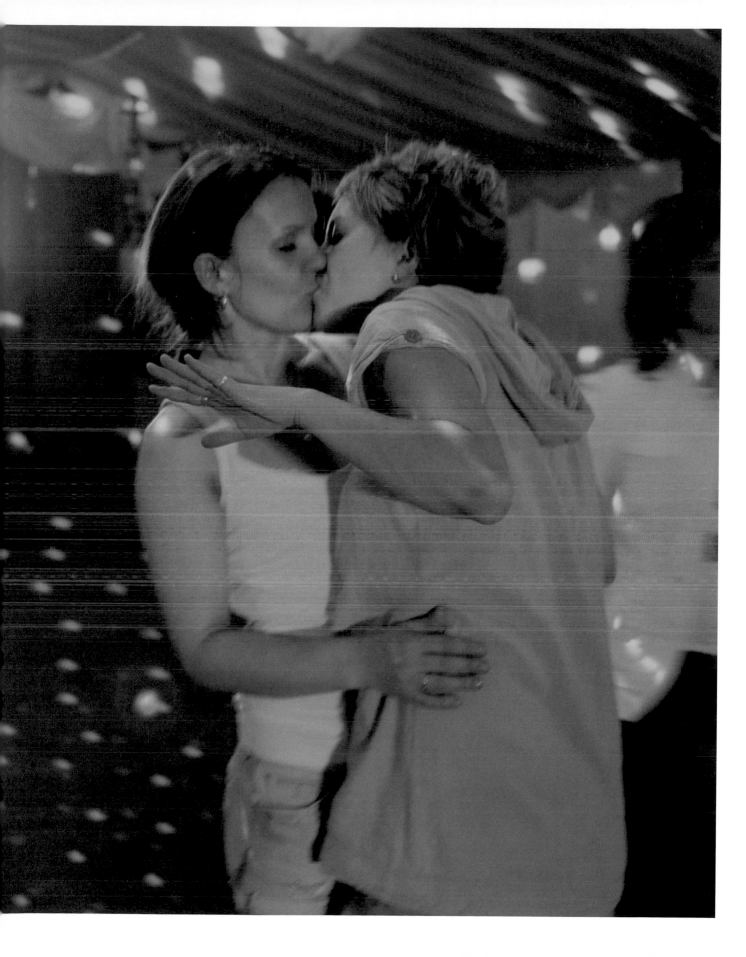

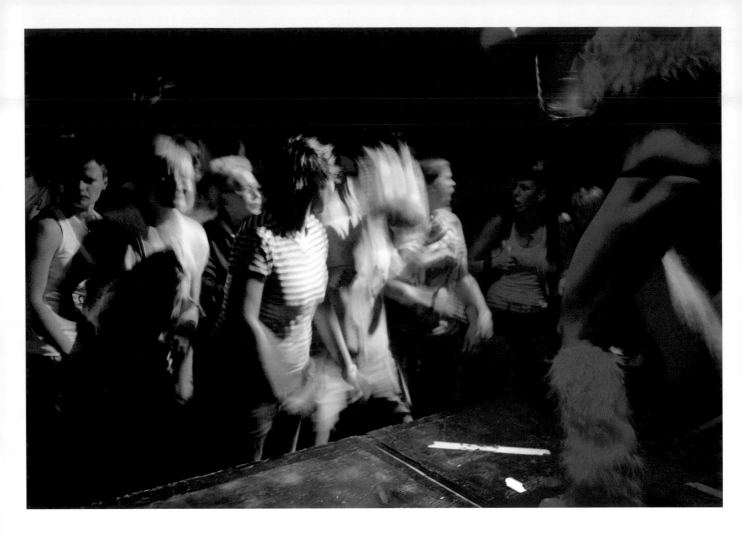

A girls-only party at a nightclub.

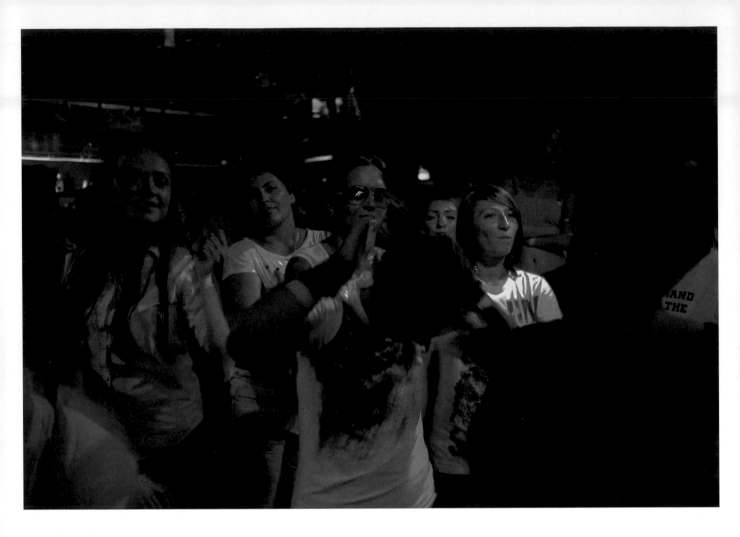

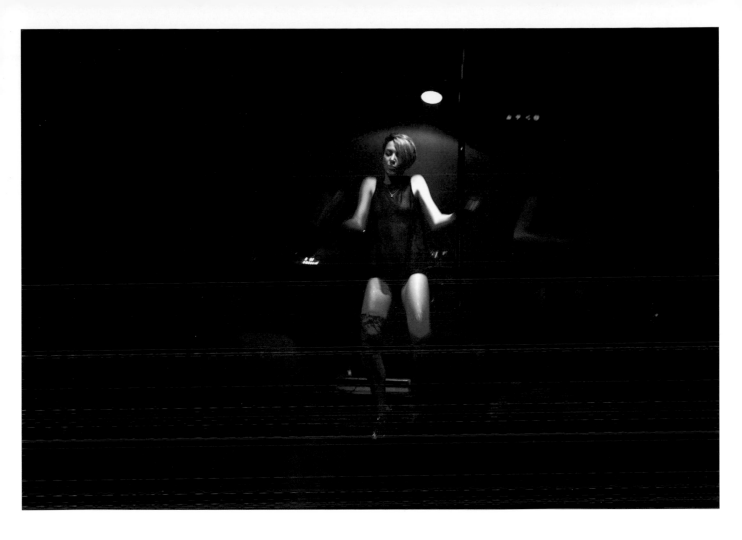

Natasha showing her
photographs to a girl,
after a party.

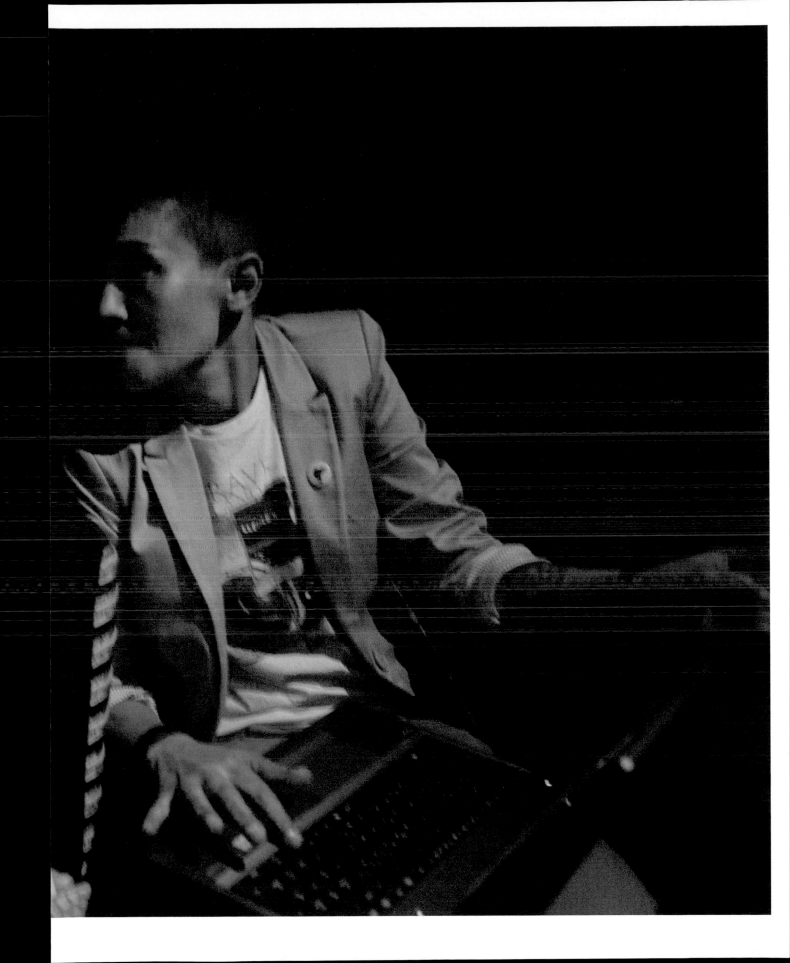

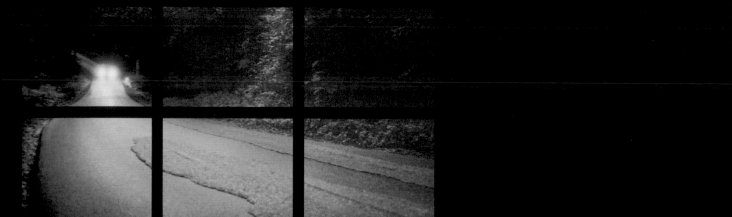
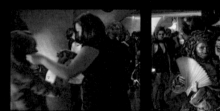
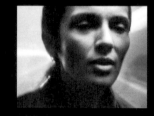

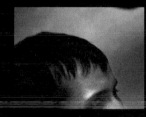

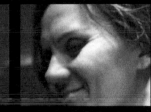

6

ШЕСТЬ

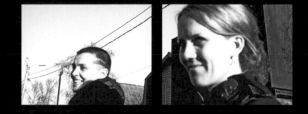

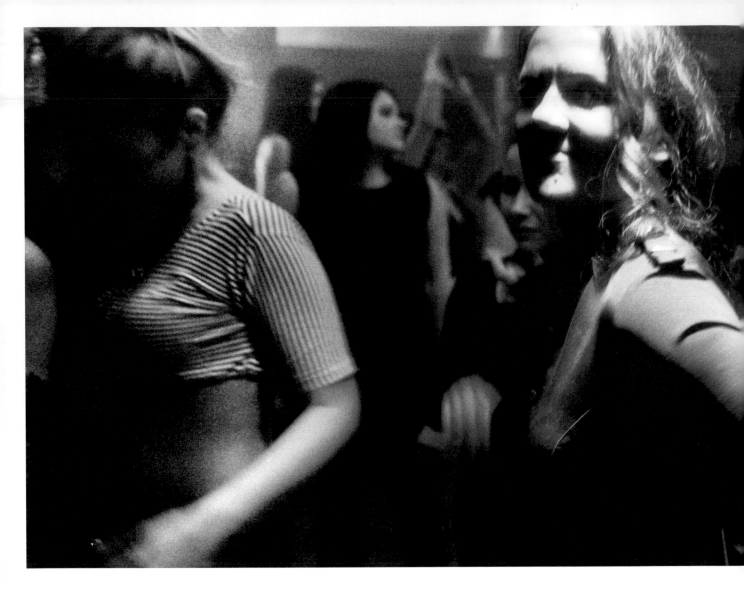

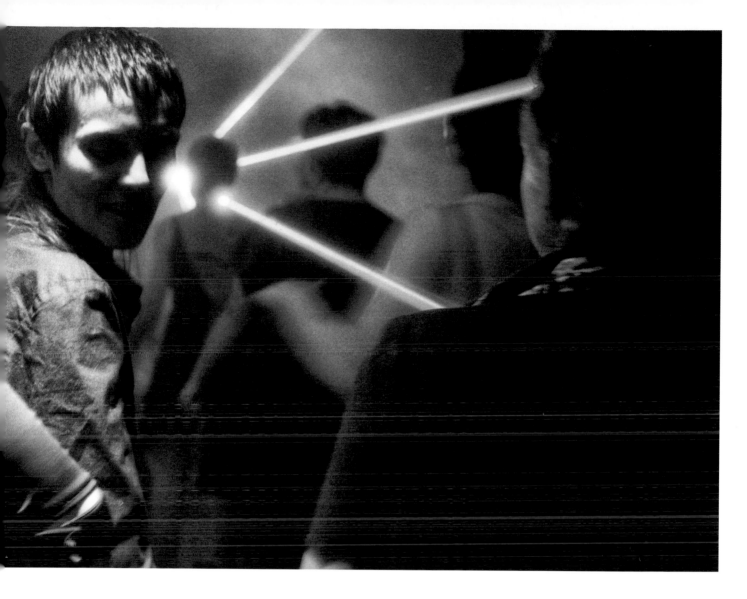

Lyudmila and Natasha dancing at a nightclub.

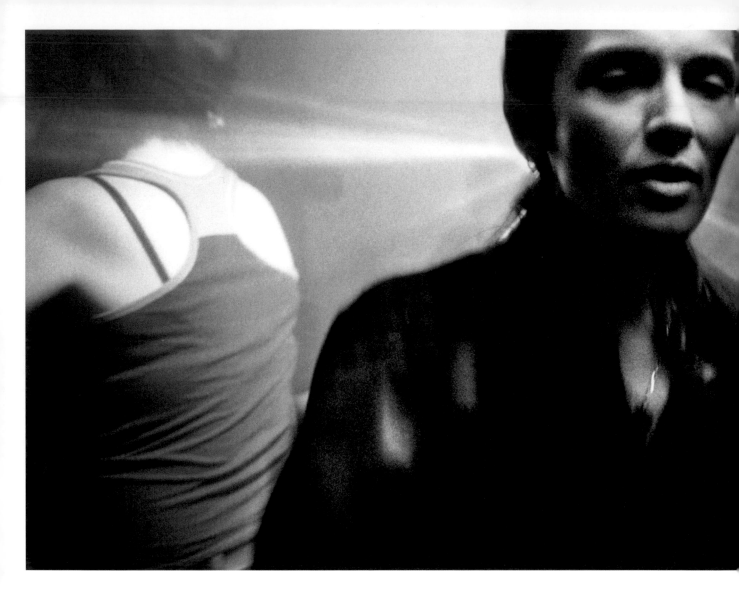

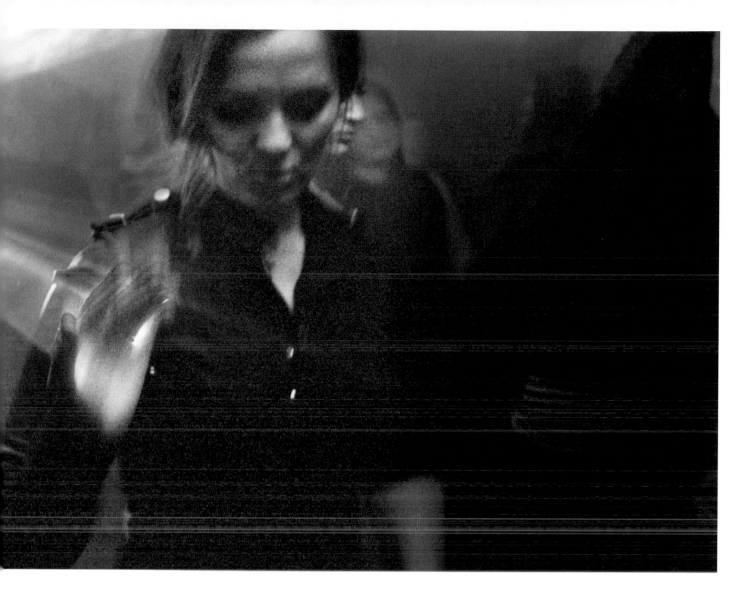

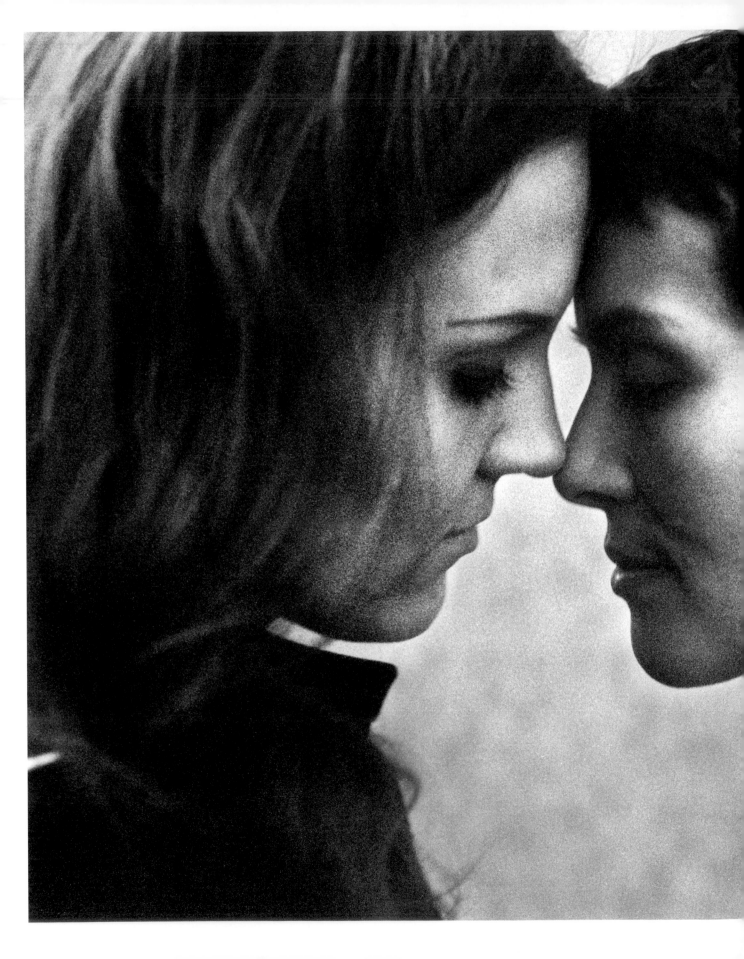

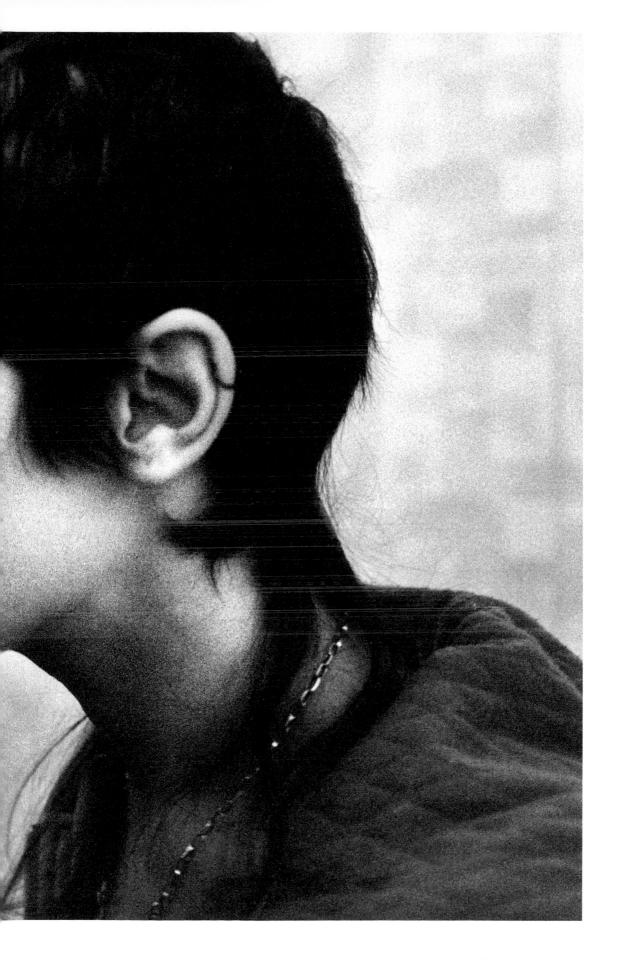

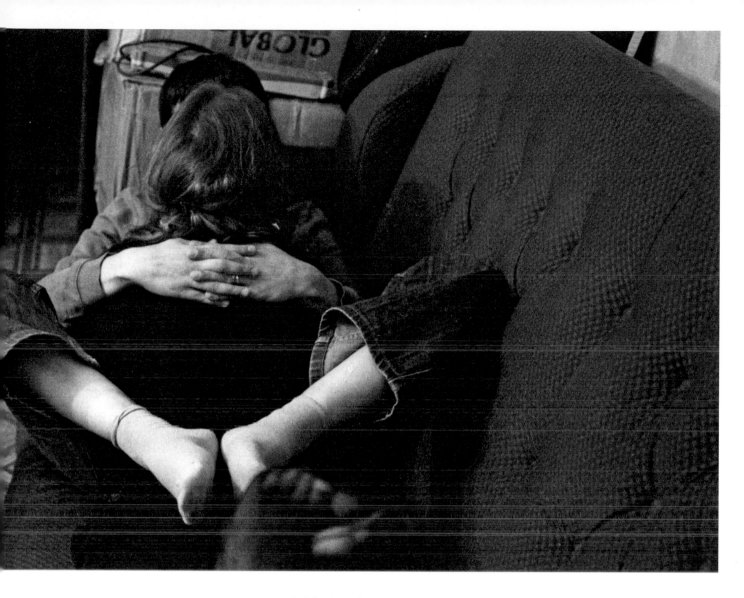

An intimate evening together. Both Lyudmila and Natasha have no financial stability—they move at least twice a year, often living out of boxes for weeks. Sometimes, when money is good, they can afford their own studio; when money is tight, they share a dodgy room in a one of Saint Petersburg's communal apartments.

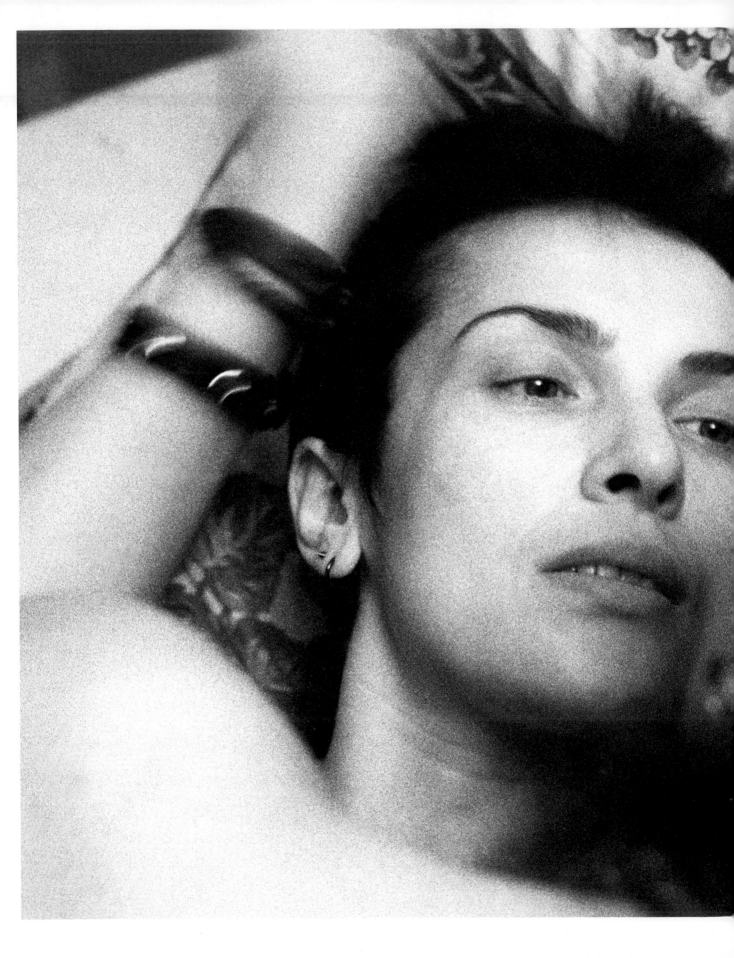

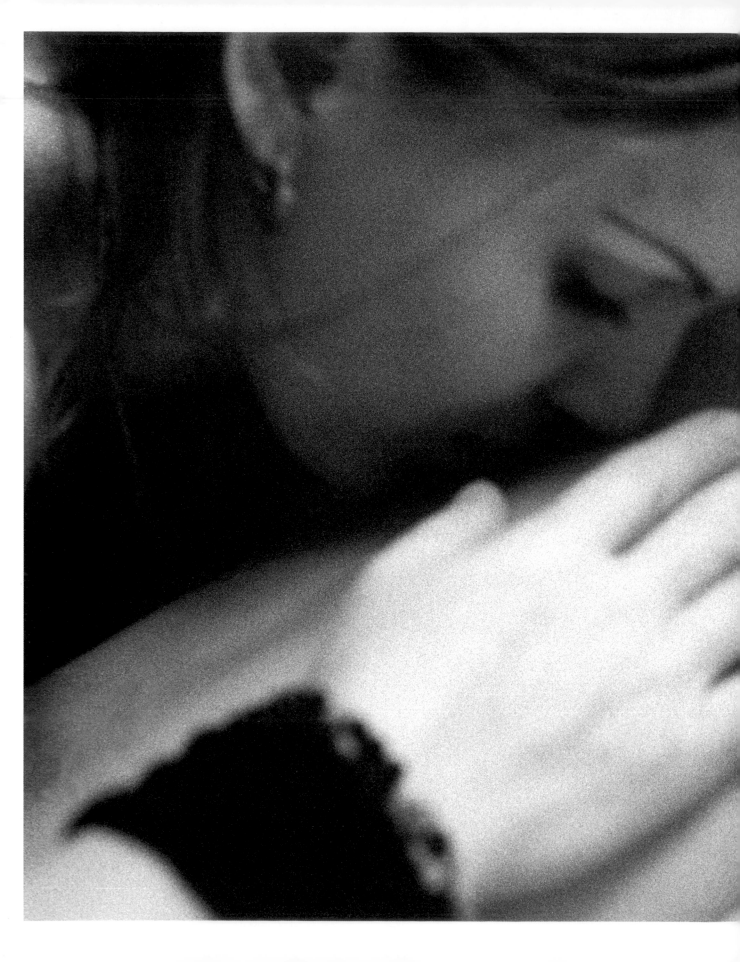

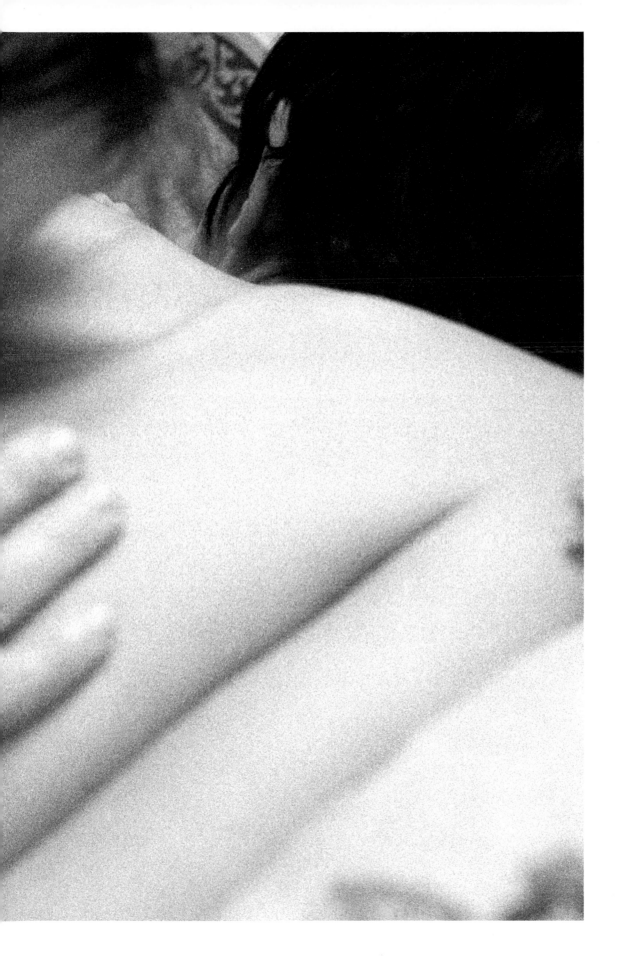

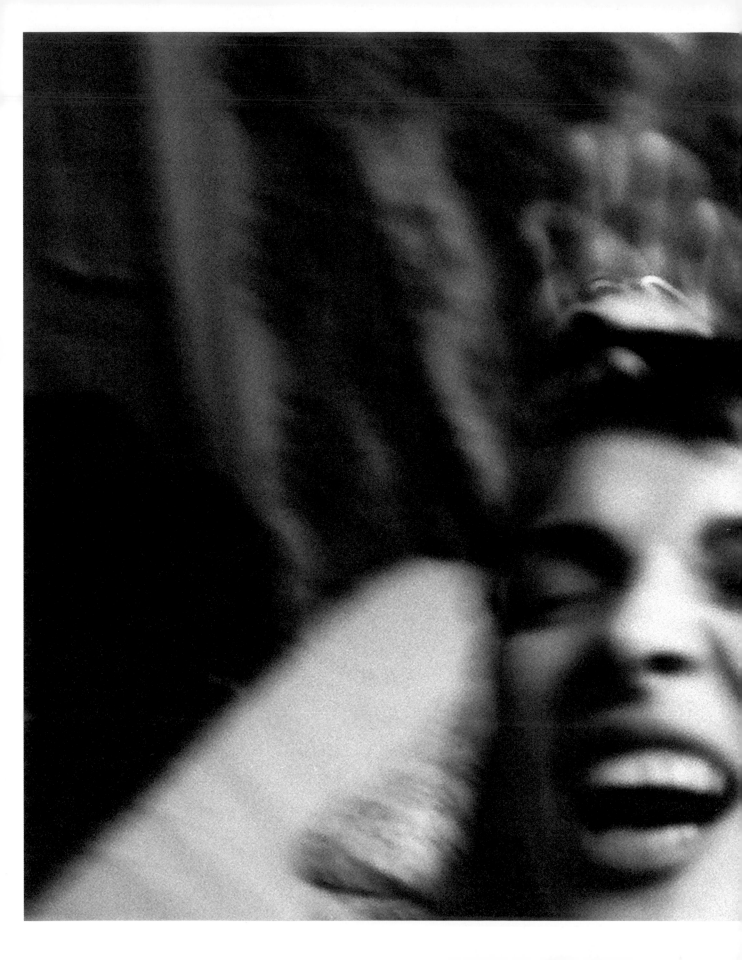

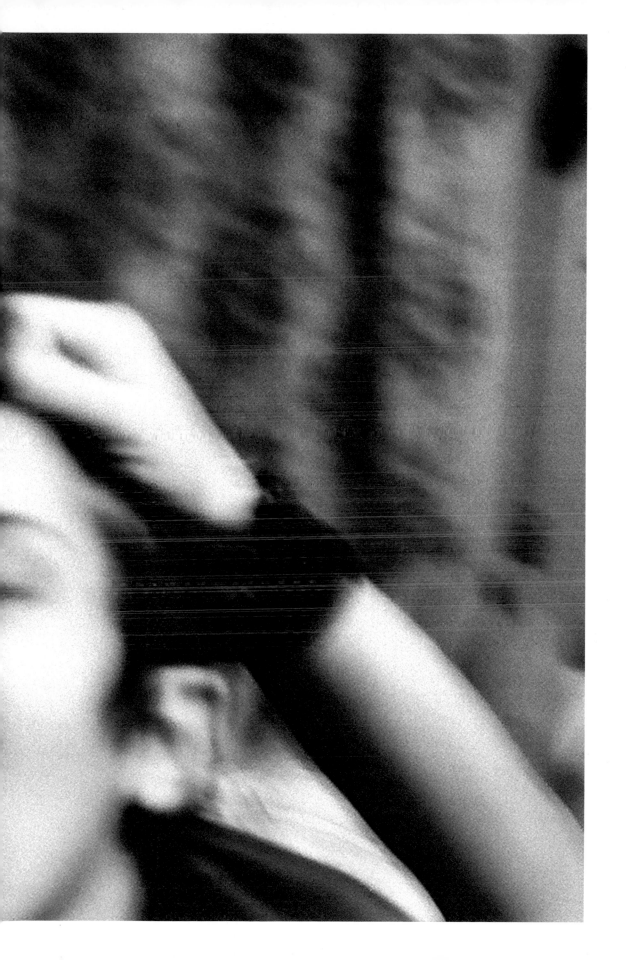

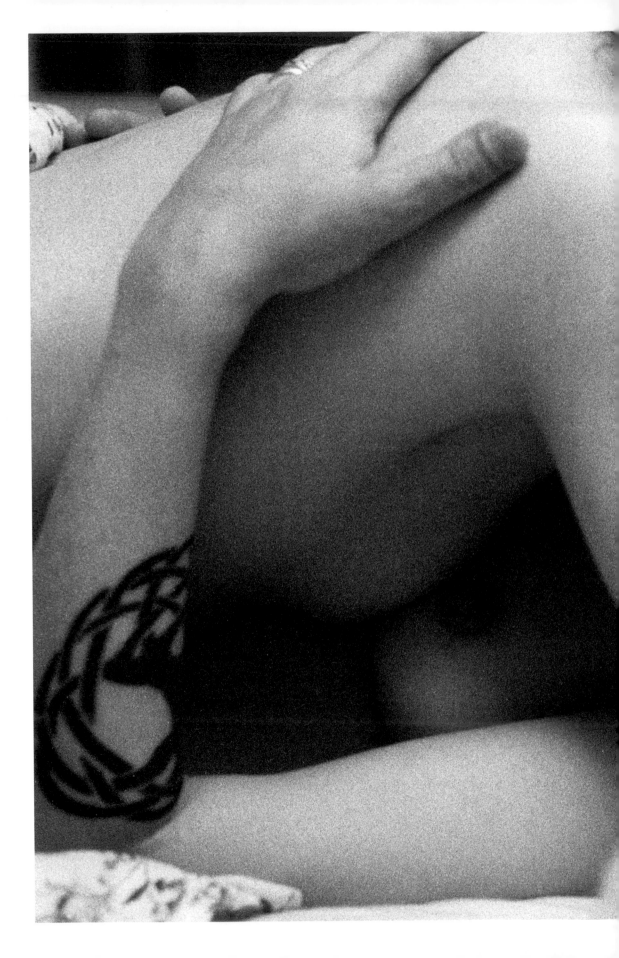

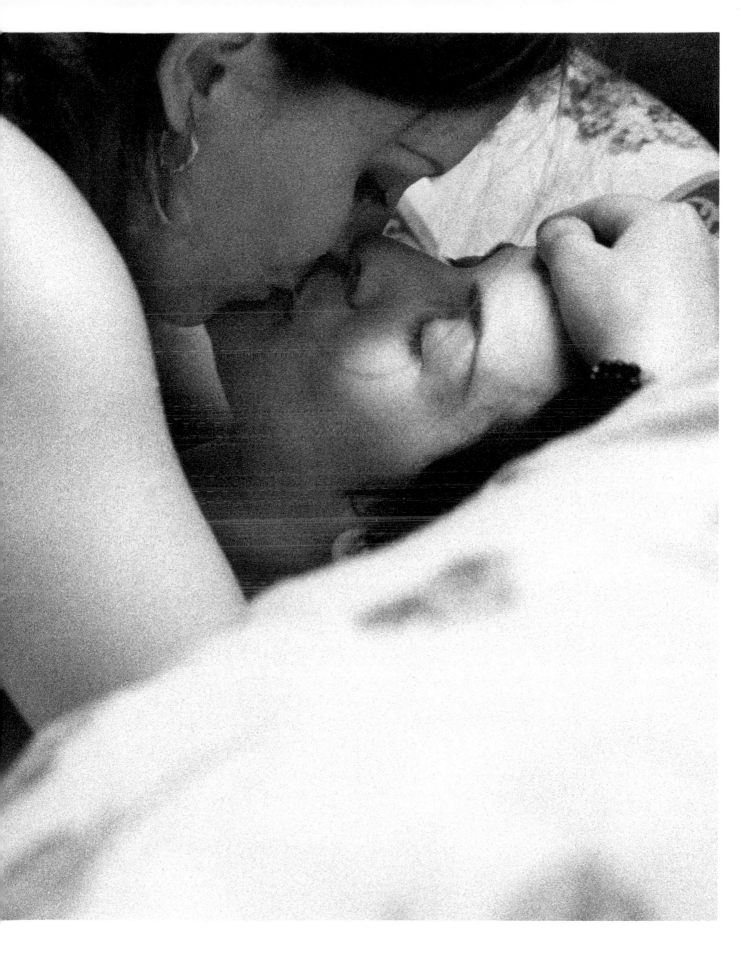

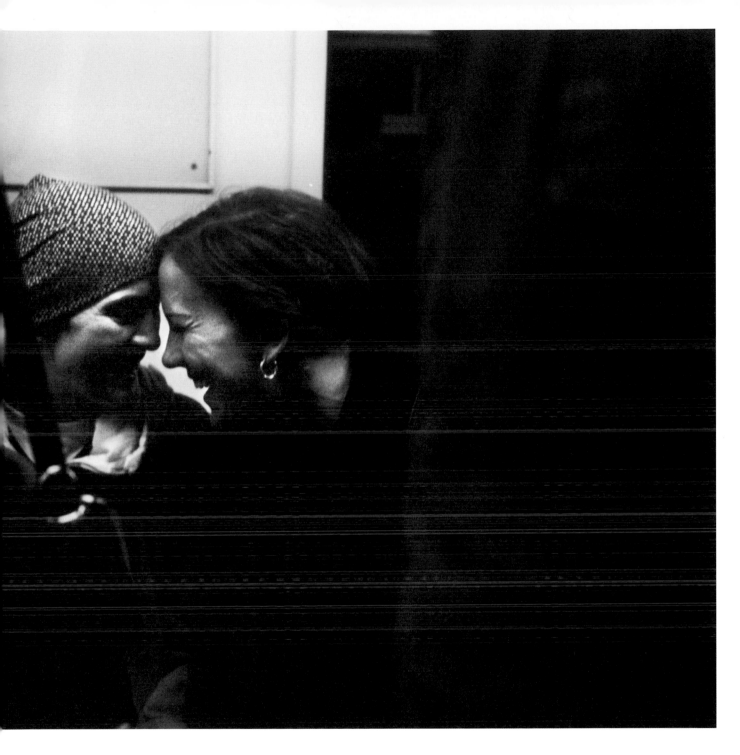

Natasha and Lyudmila laughing during a subway ride.

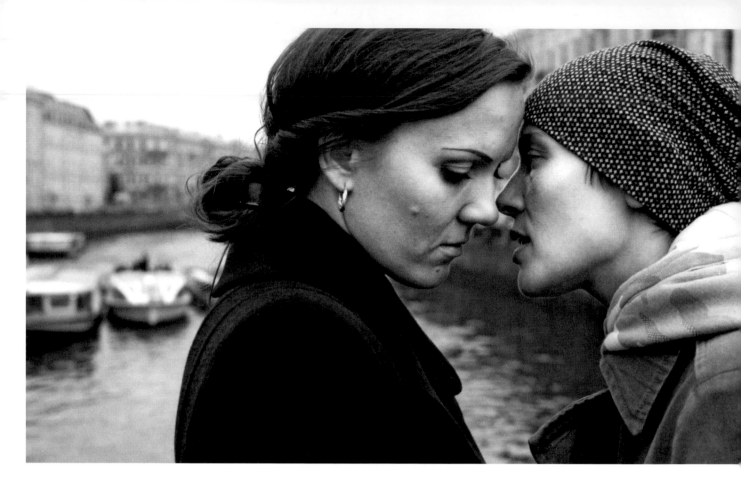

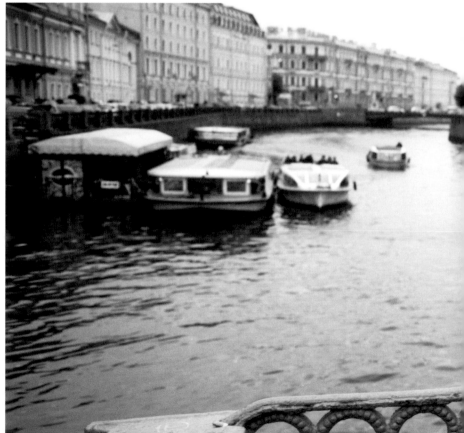

Natasha and Lyudmila on an embankment in central Saint Petersburg.

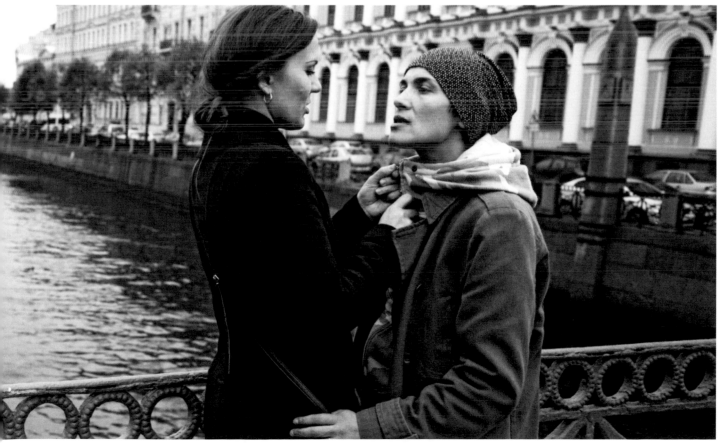

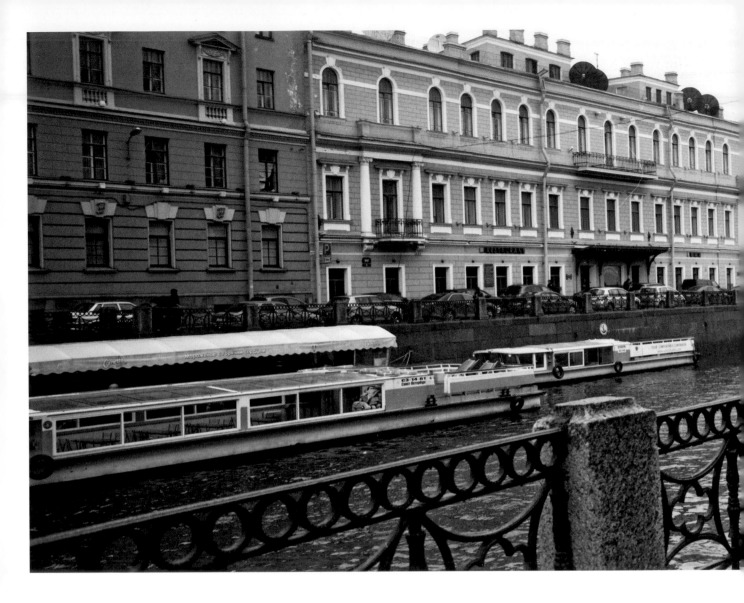

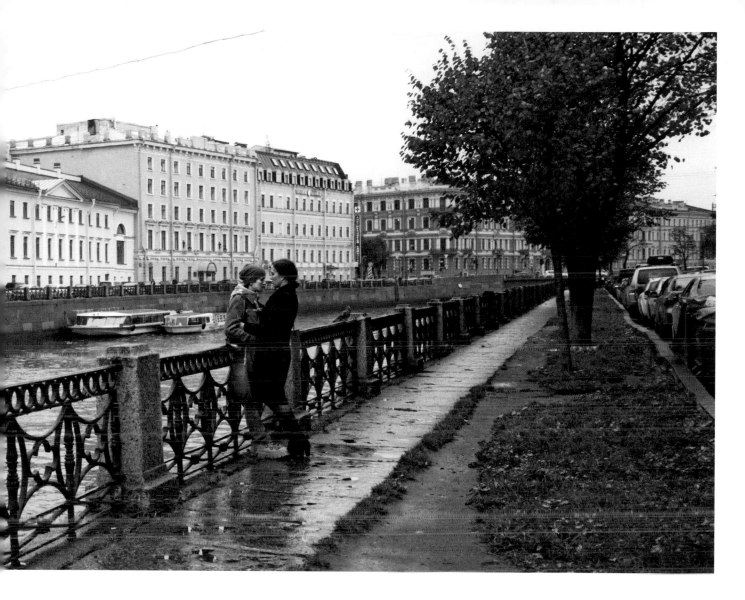

Acknowledgments

The photographs presented in this book were made possible by
a commission from Jon Stryker: philanthropist, architect, and
photography devotee.

This book was made possible in part by a grant from the

Thank you to: Natasha and Lyudmila for letting me into their lives,
with hopes that this is the beginning of a lifelong friendship; Jurek
and his colleagues for trust, support, and encouragement; Arcus
Foundation for believing in the relevancy of long-term documentary
projects; and my wife, Daria, for patience and love.
—Misha Friedman

*The Arcus Foundation is a global foundation dedicated to the idea that people can live in harmony
with one another and the natural world. The Foundation works to advance respect for diversity
among peoples and in nature (www.ArcusFoundation.org).